BONNET HOUSE

Exploring Nature and Estate Photography

LARRY SINGER

AMHERST MEDIA, INC. ■ BUFFALO, NY

About the Author

Fort Lauderdale photographer Larry Singer has worked for newspapers, magazines, and the manufacturers of greeting cards, posters, and calendars since 1971. He has taught photography at the college, adult education, and middle school levels. After his first visit to Bonnet House Museum & Gardens in 2014, Singer spent the next 18 months capturing everything he discovered on the 35-acre estate with his Canon camera. Singer's work currently appears at Rossetti Fine Art gallery in Wilton Manors, Florida. To see more of Larry's images, visit: www.larrysingerphotography.com.

Published by:
Amherst Media, Inc., PO Box 538, Buffalo, NY 14213
www.AmherstMedia.com

Publisher: Craig Alesse
Senior Editor/Production Manager: Michelle Perkins
Editors: Barbara A. Lynch-Johnt, Beth Alesse
Acquisitions Editor: Harvey Goldstein
Associate Publisher: Kate Neaverth
Editorial Assistance from: Roy Bakos, Rebecca Rudell, Jen Sexton
Business Manager: Adam Richards

ISBN-13: 978-1-68203-248-0
Library of Congress Control Number: 2016952117
Printed in The United States of America.
10 9 8 7 6 5 4 3 2 1

www.facebook.com/AmherstMediaInc
www.youtube.com/AmherstMedia
www.twitter.com/AmherstMedia

Contents

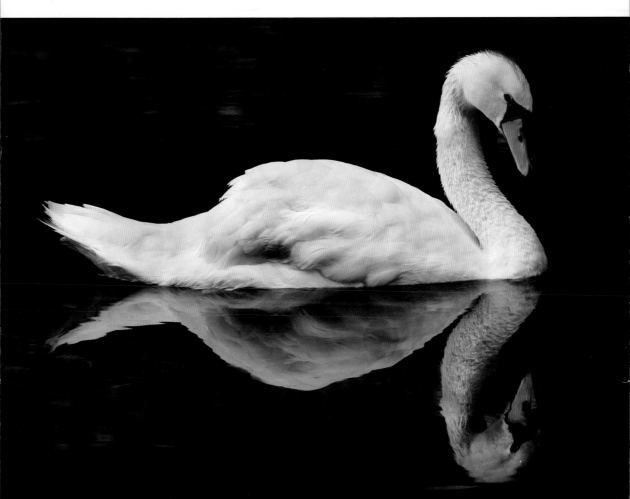

1. A Brief History of Bonnet House

On the evening of May 10, 2005, millions of viewers sat in front of their televisions intently watching the season finale of *The Amazing Race*. Near the show's climax, it was revealed that Bonnet House Museum & Gardens in Fort Lauderdale was the final destination and finish line for the winning team's million-dollar prize.

A swan glides past the stately home at Bonnet House Museum & Gardens.

A Hidden Treasure

Assuming that the show's location scouts were looking for a picturesque and hard-to-find spot for a spectacular ending, they could not have made a more perfect choice. In an area of Fort Lauderdale famous for its beaches and luxury malls, just one block from the city's busiest beach intersection, Bonnet House Museum & Gardens was built to be, and has remained, very well hidden. It is one of Fort Lauderdale's best-kept secrets.

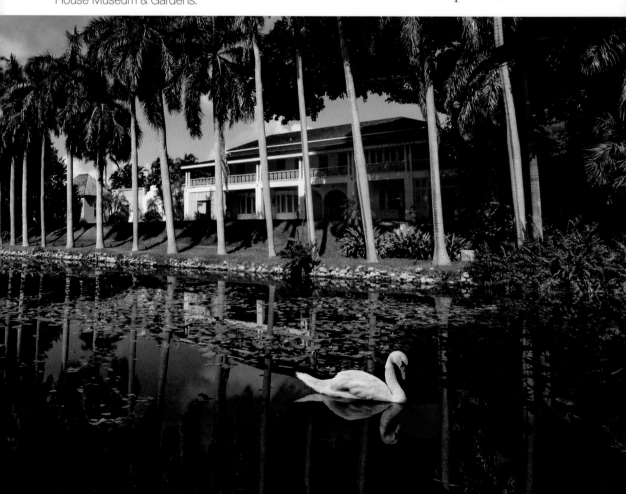

Over the past 100 years, Bonnet House Museum & Gardens has evolved from a hidden, private vacation home into a rich source of photogenic natural beauty and creative artistic inspiration. It is an oasis in the epicenter of an explosion of high-rise beachfront development. It is also, by design, as far from a conventional museum as possible.

The most likely explanation for this anomaly is that the person whose timeless vision of purpose and exquisite taste Bonnet House most reflects was successful painter and serious art collector Fredric Clay Bartlett. As visitors to the estate discover, everything this artist designed, created, or acquired in and around Bonnet House is art.

Unlike other historic homes built to visibly symbolize the owner's wealth and power, Bonnet House was designed to be a hidden Florida winter home where the owners and their guests could escape and relax. And unlike many lifeless historical Florida houses that survived into the 21st century, Bonnet House exudes an irresistibly personable and inviting hospitality that continues to seduce visitors. The home's circular, nightclub-style Bamboo Bar perfectly illustrates the degree to which Bonnet House was designed as a tropical, vacation getaway where creative people went to have fun.

When the house was built in a sparsely populated area of Fort Lauderdale, acres of undeveloped land separated the owners from the rest of the world. Today, the house is surrounded on two sides by high-rise development. Mangrove marsh and the intercoastal waterway to the west and the coastal hammock and a tall wall to the east hide the rest of the estate.

High-rise beachfront development now surrounds Bonnet House's 35 tranquil acres.

The Story

The fascinating, romantic story of Bonnet House begins in 1893, when prosperous Chicago attorney Hugh Taylor Birch traveled to a small, quiet, and primitive Fort Lauderdale to escape the enormous visiting crowds expected for the World's Columbian Exposition. A good portion of the hundreds of acres of Florida land that Birch purchased would eventually become Hugh Taylor Birch State Park and Fort Lauderdale's public beach—as well as Bonnet House.

In 1919, Hugh Taylor Birch gave 35 acres of his undeveloped beachfront Florida property as a wedding gift to his daughter Helen and her new husband, artist Fredric Clay Bartlett. At the time, Bartlett's paintings were displayed in the Art Institute of Chicago's American Exhibitions as well as in other museums throughout the country.

Construction of Bonnet House began in 1920. It was to be a retreat where, in addition to entertaining guests, Frederic Bartlett could pursue his artwork in a studio with two-story, floor-to-ceiling, northern-exposure windows, and Helen could compose music and poetry. Tragically, after only six years together, Helen died from lung cancer.

In 1931, Fredric Bartlett married Evelyn Fortune Lilly, the daughter of a president of the Indianapolis Telephone Company and board member of the pharmaceutical firm Eli Lilly and Company. With this marriage, an artistic renaissance blossomed in Bonnet House

BELOW AND FACING PAGE—Bonnet house is a haven for both art and nature lovers.

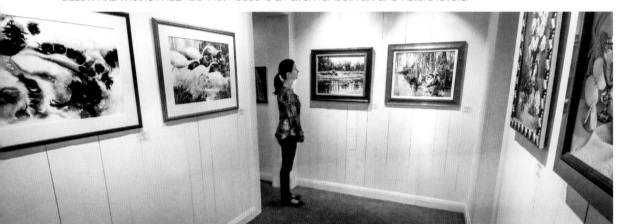

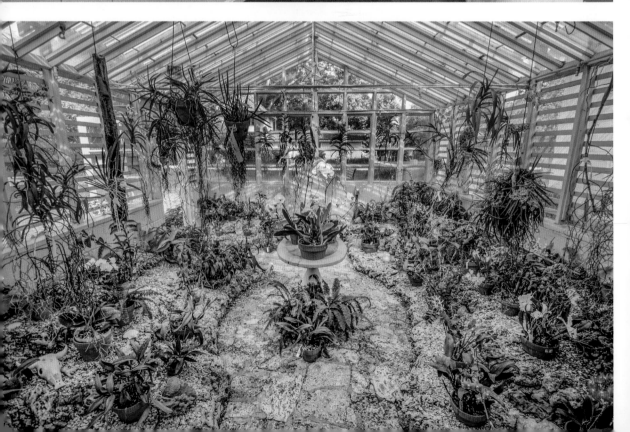

as Frederic and Evelyn entered a prolific period of creating and acquiring art.

Fredrick Bartlett died in 1953. In 1983, his widow gave the entire Bonnet House estate to the Florida Trust for Historic Preservation. It was, at the time, the largest charitable gift in Florida history. In 2004, the National Trust for Historic Preservation included Bonnet House in its Save America's Treasures program.

About the Museum & Gardens

Surrounded by the home's fortress-like white walls, a variety of exotic orchids, cacti, and other plants can be found growing year round. Week by week, their display of brilliant hues, dazzling patterns, intriguing textures, and artistic designs changes dramatically, offering limitless options for photographers.

"Bonnet House has universal appeal," said curator Denyse Cunningham. "Some people are interested in the art. Other people are interested in the nature. Some people are interested in architecture. I like the creatures and the birds and the beautiful plants, but some days I'm really into the art. Lately I've been very into the architecture because we are involved in reconstruction. We're trying to bring everything back to the way it was in the 1930s and '40s."

In addition to the variety of birds, reptiles, and colorful insects that refuse to stop using Bonnet House as a free bed-and-breakfast, the enormous variety of orchids grown in two on-site greenhouses provide endless once-in-a-lifetime photo opportunities. For those with creativity to spare and decent eye/hand coordination, classes also are regularly held for artists who work with paint and canvas.

Currently, weddings, magazine and model shoots, grants, concerts, art exhibitions, fundraising luncheons, donations, visitor entry fees, and a small army of unpaid volunteers provide the funds and most of the manpower to keep the huge estate alive, healthy, and immaculate. Additionally, The Bonnet House Alliance (a social and auxiliary group of prominent local families) has, as its primary mission, the raising

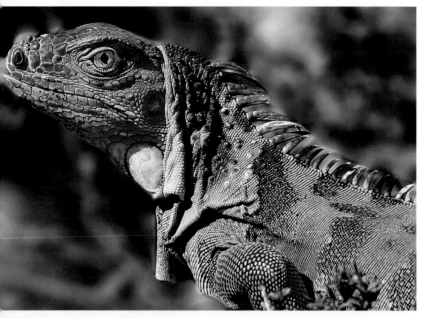

of funds to support the 35-acre estate and gardens. The group's annua over-the-top gala luncheon takes both extravagance and elegance to new levels.

"I find it fascinating that the house has survived," says Bonnet House's CEO, Patrick Shavloske. "When you look at the area surrounding the property, it's amazing that Bonnet House still exists."

A Photographer's Dream

Because the Bonnet House estate has four distinct environmental zones, or tropical ecological habitats, there is an incredible variety in the sizes, textures, and colors of its flora. And the wildlife, safe within its walls, often pose for portraits with a nonchalant cooperation beyond any nature photographer's wildest dreams. The current residents of Bonnet House hooked me and kept me coming back nearly three or four days a week for 18 months. The images I was able to capture there, and what it took to get them, is what this book is about.

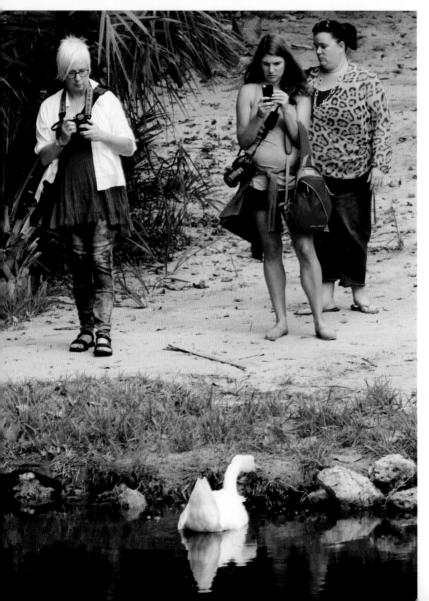

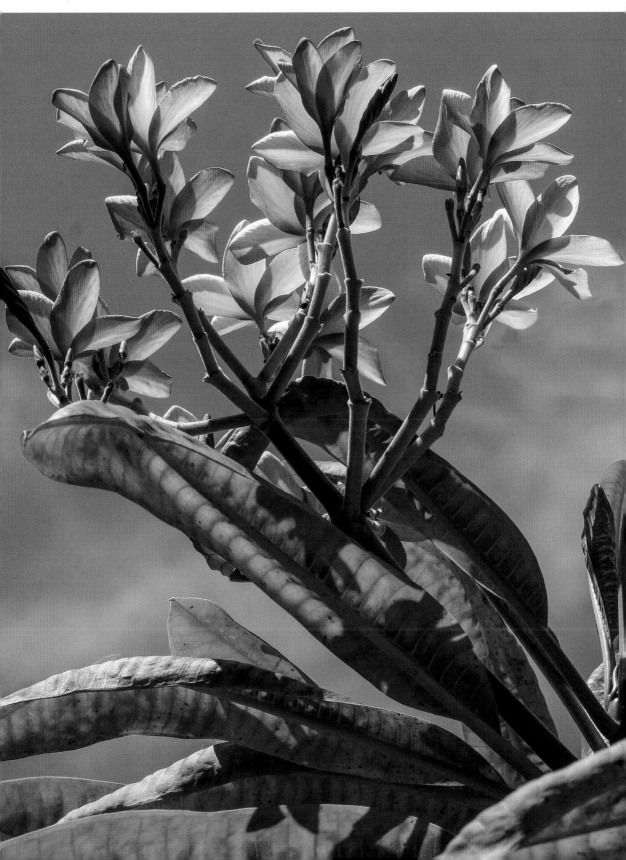

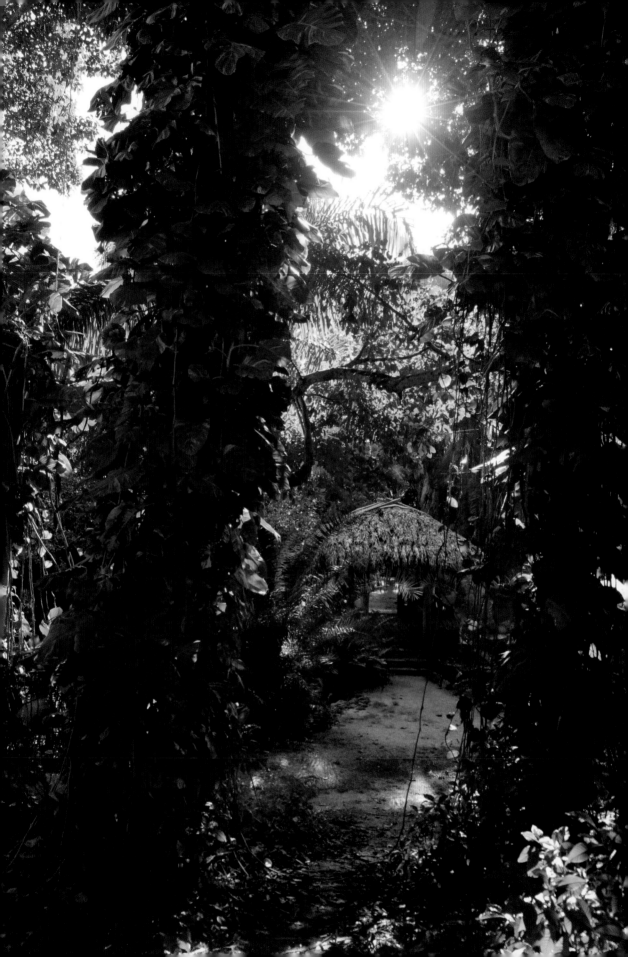

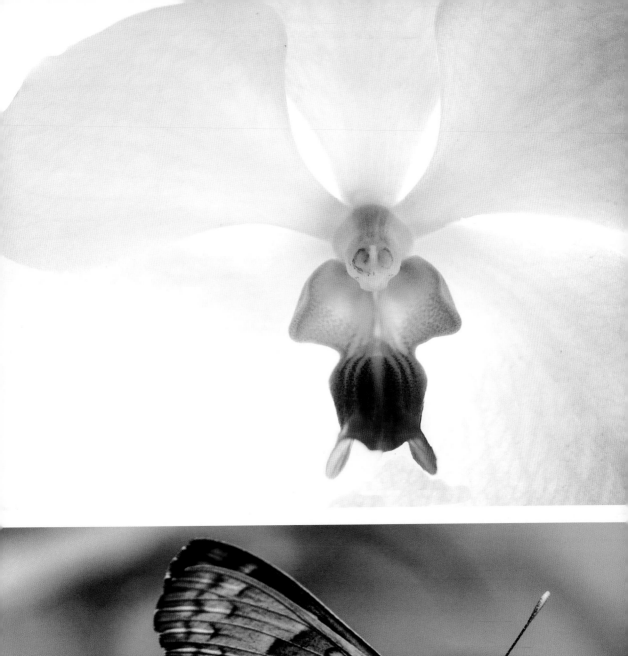
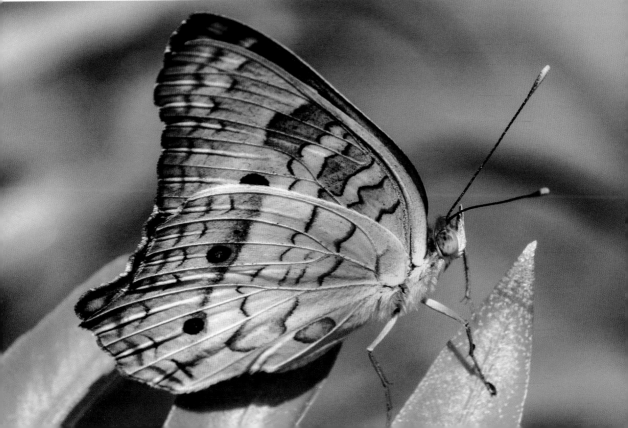

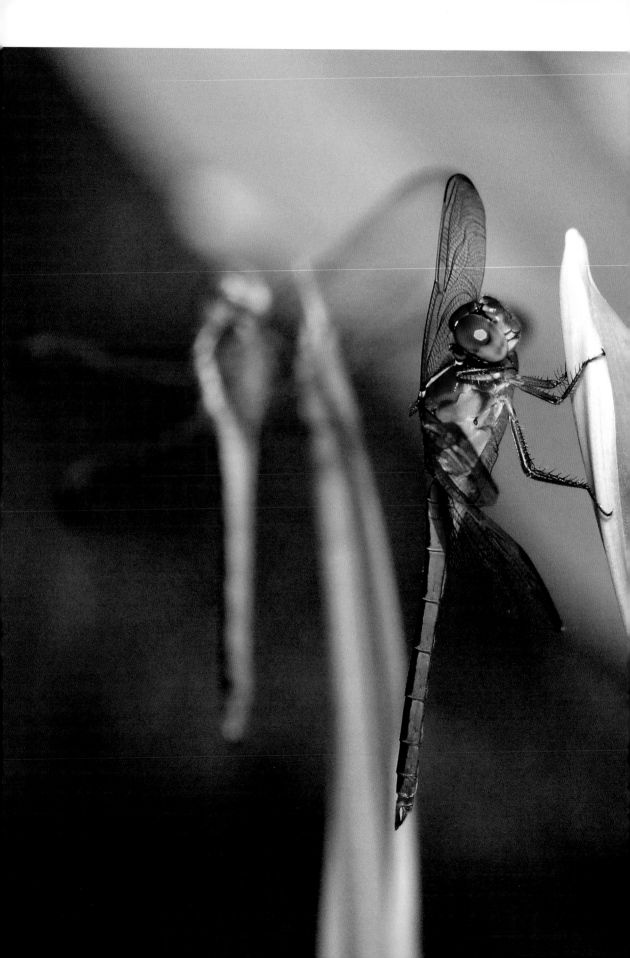

2. The Discovery

For most of my adult life, I have been a professional photographer. I grew up watching my father shoot weddings with a shoebox-sized press camera.

During my 45-year career, I've worked for newspapers, magazines, greeting card publishers, and record companies. In 1971, while in college, I worked for *Circus* as a rock-and-roll photographer. In addition to nationally marketed posters of Rod Stewart, Alice Cooper, and an orangutan named Tabitha, five of my images have appeared inside and on the cover of a Canadian-published butterfly calendar marketed in Walmart.

In 2016, the Rock and Roll Hall of Fame chose my image of guitarist Eddie Van Halen to symbolize the energy and pure joy of rock and roll on the cover of its Visitor Planning Guide and billboards around Cleveland. Both my art and rock-and-roll photographs have been marketed in art galleries and by photo agencies in the United States and Europe. I have photographed unpredictable animals in zoos, the skittish residents of butterfly emporiums, and the incredible beauty and majesty of the California Redwood Forest—but I have never seen anything like Bonnet House.

My First Visit

I first became aware of Bonnet House Museum & Gardens after moving to Fort Lauderdale in 1969. Still, it took 45 years for me to discover its exact location. In truth, I had no desire to track it down until Tom Rossetti, the owner of Rossetti Fine Art (a gallery in Wilton Manors, Florida) convinced me I would find Bonnet House to be a rich and reliable source of creative inspiration.

When I made my first trip, just four miles from my home, I had no idea what I would find. In fact, I was so completely unaware that I unthinkingly committed the unforgivable sin of leaving my camera gear at home.

Walking from the parking lot, I saw that Bonnet House Museum & Gardens was far different than I had imagined. To my left, long rows of partially submerged mangrove roots and reeds cast mirror-like reflections on a dark pond. Inside the Welcome Center, I discovered Bonnet House offered a one-year Fine Arts membership, which would allow me, without restriction, to prowl around the estate with my camera. I left Bonnet House with that membership—and looking forward to returning to see what creative dividends my investment would pay.

What Sold Me

I never imagined that I would, in the next 18 months, spend three or four days a week at Bonnet House. I had no idea I would wind up photographing extremely exotic and

improbably shaped tropical plants, unbelievably colored dragonflies, a bizarre variety of tropical birds, prehistoric-looking reptiles, or delicate orchids (bearing a strong resemblance to robed monks, fairies, and a host of supernatural winged creatures).

On the first day I showed up with my camera, it was one tiny and easily overlooked creature that wound up turning me into a true believer in the photographic magic of Bonnet House. Although it was frozen like a small statue in an apiary, it caught my attention and seriously changed my life. The critter was a brown honeybee, standing on a flat yellow sunflower busily gathering pollen. Through past encounters, I learned that bees tend to gather pollen by diving deep into a flower head first. This bee, however, was extraordinarily visible and facing directly toward me.

Inexplicably, the busy bee remained nearly motionless as I began inching toward it. When I was about three feet away, I managed to capture five exposures before the bee determined it had business elsewhere and disappeared. When I inspected the first picture on my camera's memory card moments later, I discovered that both the flower on which the bee stood and the yellow sunflowers surrounding it were reflected, with remarkable clarity, in the bee's eyes. Less than a week later, the editor of *Bee Culture* magazine let me know my bee picture would be on the cover of the May 2015 issue. (You can see the image and the magazine cover on page 116 of this book.)

A Close Encounter

On my next trip to the estate, while wondering what I would find to photograph, I had my first extremely close encounter with one of the two resident swans. From that moment, I knew that Bonnet House contained considerably more than a mere abundance of truly amazing pictures waiting to be taken.

When I discovered the swan, it was about 150 feet away. It was floating in silent circles in what I call the "main" lily-filled pond a few feet from the home's front porch. Years ago, when alligators poked their eyes up out of the pond, the lilies rested delicately atop their heads—like the lady's cloth hat for which the house is now named.

When the swan noticed me, it swam in my direction. After I recorded about a half dozen images, the swan began swimming much faster than I would have preferred. A few seconds later, the big bird arrived a few feet away, waddled out of water, and sat down on the grass not far from where I stood. After staring at me for a few seconds, he began (without warning and using practiced precision) to perform a series of unexpectedly glamorous high-fashion poses. It was as though he dropped by a studio to get new head shots for his portfolio. Momentarily thrilled at his bizarre behavior, I began shooting him from what I hoped was a safe distance. After capturing him in a dozen or so different poses, I stopped shooting to look at the screen on the back of my camera and determine the quality of what I just shot. No sooner did I begin to look at the second image, than the swan bellowed—a series of squawking, hissing honks similar to an air horn. When I looked up at him, he locked eyes with me and vocalized his extreme displeasure.

Before I could start backpedaling in fear, the swan stood up. But instead of screaming at me, he started murmuring softly and

seductively, then sat down again. His behavior caused me to wonder if the big white diva might be keenly aware of his own beauty and enjoying having his picture taken.

As I began shooting again, he showed me his best Derek Zoolander *Blue Steel* attitude.

When I felt I had more than enough swan shots to edit when I got home, I stopped shooting, and verbally thanked the swan for its cooperation. When I turned to leave, I was startled to hear his angry squawking and enormous black-speckled feet sprinting toward me

The animal residents of Bonnet House are often surprisingly cooperative photo subjects.

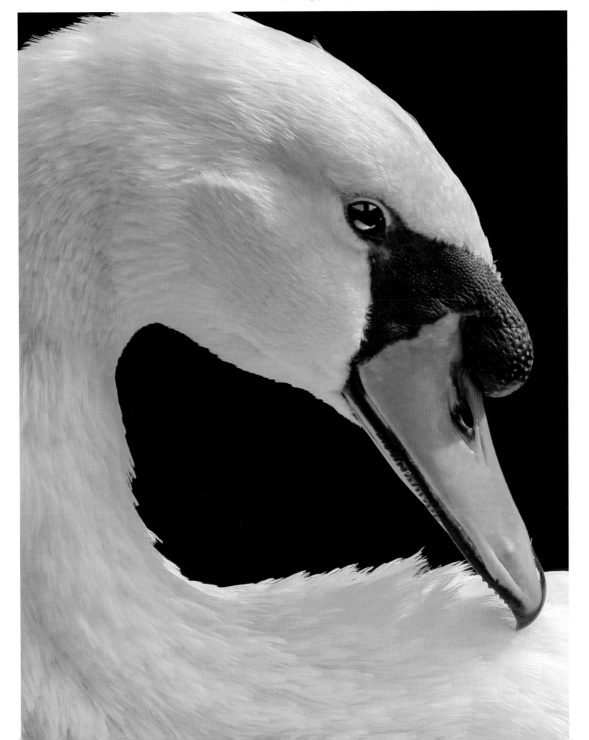

again. At that moment, I recalled an old film clip of a homicidal swan relentlessly attacking a golfer armed only with a Ping putter.

Testing my "diva" theory, I resumed taking pictures of the swan. Immediately, he sat down and began posing again. It then struck me that not only did this swan adore having me take his picture, he really lost his temper when I stopped.

As I was attempting to develop a plan that would allow me to separate myself from a creature capable of attacking me from both the ground and the air, I was startled by another, slightly less jarring series of loud squawks some distance away. Turning away from swan #1, I saw Bonnet House swan #2 coming in fast as he executed a splashy lily-pond landing. While tracking the loudly squawking white blur through my lens, I had time to fire off only two shots before his wake completely obscured him.

After escaping from my temperamental avian prima donna, I drove home and download-ed the image data from my camera's memory card. When the miniature pictures were all displayed in neat rows, I began by enlarging my images of the swan landing. In both images, the only parts of the swan not blurred by his speed are his white face, black eyes and orange beak. When I examined his portrait shots, and the images of him swimming toward me, I was elated to see nothing in the background of any image to distract the viewer. I was also pleasantly surprised with the swan's near-perfect reflection in the black pond water.

Something New Every Time

I then began visiting Bonnet House three or four times a week for the next 18 months. After shooting thousands of images, I frequently wondered how I could possibly find anything new at Bonnet House to photograph. Yet, every time I showed up at Bonnet House, I returned home feeling victorious.

Plants and Butterflies

In addition to the animals, I was able to photograph an incredible variety of orchids and other exotic plants and flowers. Mimi Gardner, the resident horticulturist, even tends to a bizarre, insect-eating, foul-smelling cacti with star-shaped blooms. Another cactus, which only blooms at night, resembles a swarm of long green snakes.

In my time at Bonnet House, I discovered colorful and fascinating insects and arachnids, including small, incredibly colorful spiders in virtually invisible webs. I believe that many of the butterflies I photographed at Bonnet

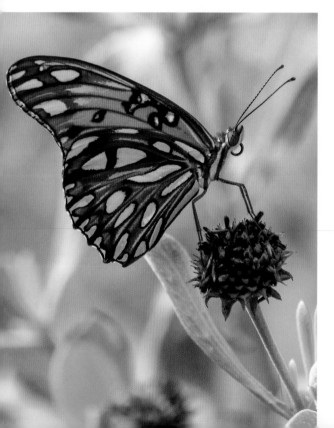

Many of the butterflies had no problem posing inches away from my camera.

House were, like the swan, keenly aware of their beauty, extremely vain, and absolutely willing to pose for my camera. Like the brightly colored dragonflies that frequently took a break to bask in a ray of sun, the butterflies that posed, mere inches away, seemed to understand that harming them was not in my game plan.

Elusive Iguanas

After only a few extremely brief encounters, I fully embraced the concept that wild iguanas are among the most antisocial of common Florida animals. Approximately one hundred iguanas of varying size and color live at Bonnet House. Fortunately, iguanas are vegans and have no teeth. Unfortunately, they never stop trying to devour the estate's flowers and the tasty buds of other carefully cultivated vegetation. Unlike most animals Floridians might likely encounter, iguanas can run unbelievably fast on land, swim underwater as fast as a torpedo shot from a submarine, and use their long, very sharp curved claws to noisily scramble up trees with incredible speed.

Because easily frightened iguanas almost magically disappear with little

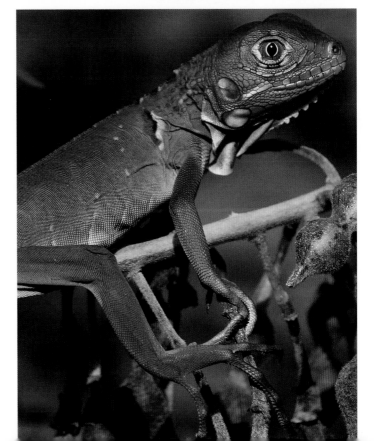

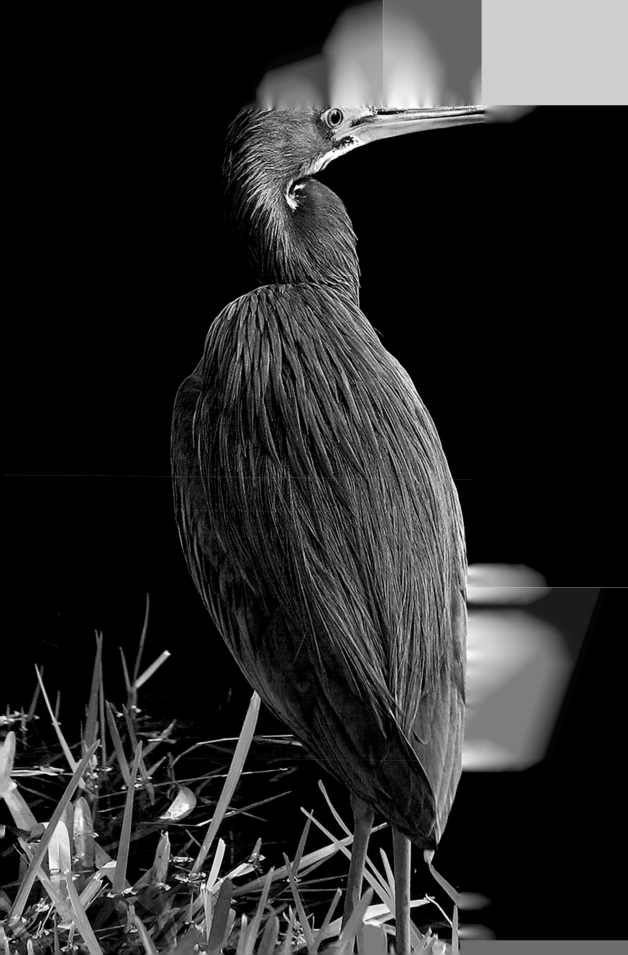

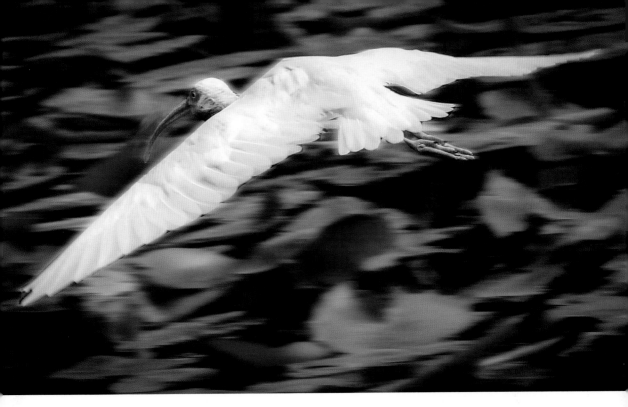

My favorite Bonnet House birds are herons and ibises.

provocation, I am aware of my extreme good fortune whenever an iguana decides to give me a brief opportunity to capture its bizarre beauty. After doggedly tracking a variety of green, silver, and gold iguanas for months, I was only successful in getting side or back shots of them from a distance. Although I knew the odds against it were enormous, I really wanted a head-and-shoulders, head-on portrait of a wild iguana.

My dream went unfulfilled until one slowly fleeing iguana paused long enough for me to maneuver directly in front of it—as unobtrusively as possible and with exquisitely feigned indifference. As I executed this slow-motion maneuver, I was certain the iguana, which never stopped staring at me, would instantly leap into the nearby pond. Unbelievably, this large, shy, and extraordinarily standoffish reptile mightily resisted the urge to depart

with a splashy belly flop—just long enough for me to get the shot I wanted. A few days later, I managed to pull off the same trick with another unbelievably trusting iguana. After that, my luck with the art of iguana portraiture ran out. See page 89 for an example of a head-on iguana portrait.

Birds and Other Wildlife

My favorite birds to photograph at Bonnet House are the beautiful blue herons and large white ibises with long, curved beaks. Because herons hiding in trees are difficult (if not impossible) to see and photograph, they are mainly photographed either in midair or landing.

One of my favorite ibis pictures (see page 60) features three white birds striking what appears to be a well-rehearsed cover pose for their *Birds of a Feather* album. A few days

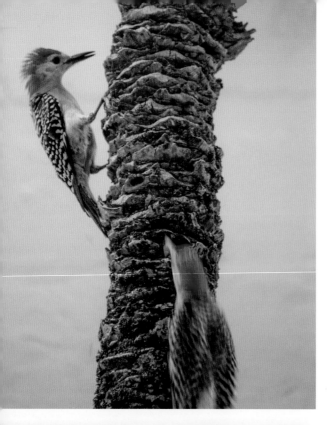

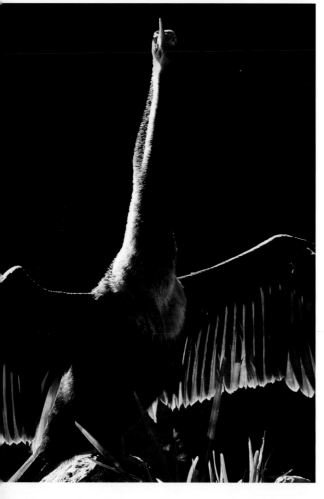

Woodpeckers and anhinga frequent the grounds of Bonnet House.

later, I spotted an ibis coming in for a landing. Under his outstretched wings are embarrassingly large areas of normally covered pink skin (see page 61).

Shortly I after began visiting Bonnet House, I found a dark brown, perfectly backlit anhinga drying its long outstretched wings. Unlike many other birds that dive for fish, the anhinga lacks water-repellent wings, which prevents it from flying directly after a meal. It was during this earthbound time that I found the bird casually drying its wings while completely ignoring an enormous, cold-blooded, golden iguana warming itself a few feet away (see page 86).

Before being decimated by hurricanes and attrition, a herd of wild monkeys once considered the grounds of the Bonnet House estate to be their home. Only three survive. When they appear, they blend in with their surroundings and are, at best, challenging to photograph.

I have also found lots of other wildlife to photograph at Bonnet House, including woodpeckers, cardinals, blue jays, hawks, moss-crusted turtles, tadpoles, and raccoons.

Art, Architecture, and Activities

While I primarily concentrated on photographing nature at Bonnet House, I would occasionally find art in people preparing for an elegant catered wedding, performers warming up for a jazz concert, an exhibit, or a gala fundraising luncheon.

Because the original occupants supported, created, and collected art, the production and

display of art remain critical to the life, spirit, and personality of Bonnet House. Painting classes are conducted on-site and the estate's expansive gallery hosts art competitions and presentations.

A Slice of Paradise

If merely considered just another tourist attraction or dusty-and-musty historic Florida home, Bonnet House Museum & Gardens can be simply described as a Fort Lauderdale Beach estate and once home to artists Evelyn and Frederick Bartlett. What I discovered over a year and half, however, proved to me that Bonnet House is not just a beautiful, perfectly preserved relic. It is a 35-acre living organism, as dynamic and vital today as it was when F. Scott Fitzgerald chronicled the lives of the wealthy and privileged. Bonnet House was designed to be a secluded palace in paradise for its guests to enjoy in complete and total privacy. That has not changed—and, if history is any indication, it probably never will.

While I focused on nature photography, sometimes other subjects caught my attention.

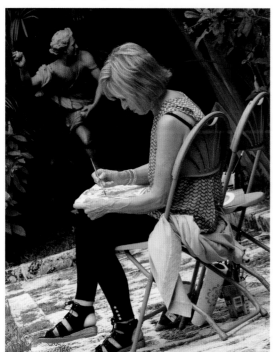

3. Flowers

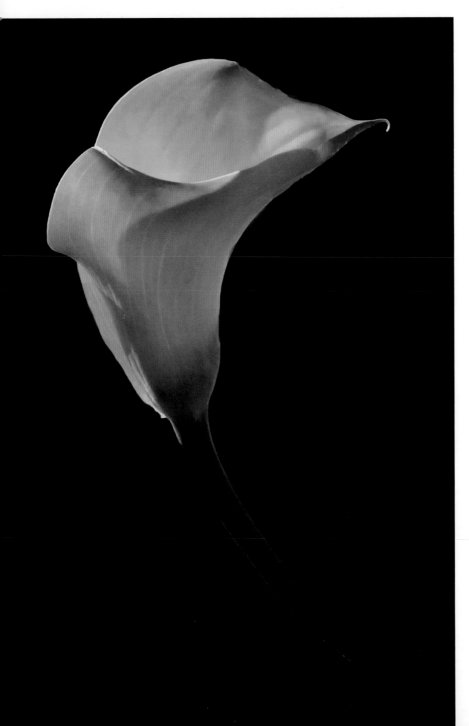

Elegant Yellow Lily

A single elegant yellow lily was one of the diverse floral decorations at a luncheon at Bonnet House on February 22, 2016. I used a Canon EOS 70D camera with a Canon 55–250mm lens set to a focal length of 250mm. With an ISO rating of 3200, my exposure settings were $^1/_{1600}$ second at f/4.

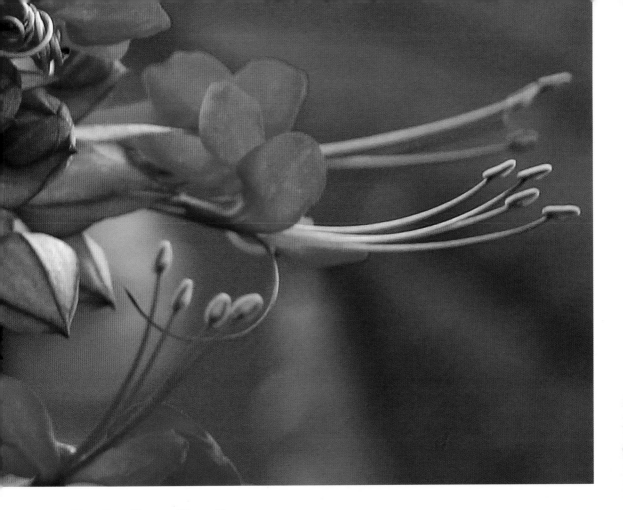

Three Bleeding Hearts Close Up (above)

The oval anther of four bleeding-heart flowers extends an invitation for pollination at Bonnet House Museum & Gardens on May 17, 2015. I used a Canon EOS 20D camera with a Canon 55–250mm lens set to a focal length of 154mm. With an ISO rating of 400, my exposure settings were $1/200$ second at f/5.6.

Orange Hibiscus Side View (right)

A backlit orange hibiscus bloom glows in the hibiscus garden of Bonnet House, shortly before a rainstorm on June 6, 2015. I used a Canon EOS 20D camera with a Canon 55–250mm lens set to a focal length of 171mm. With an ISO rating of 400, my exposure settings were $1/500$ second at f/9.

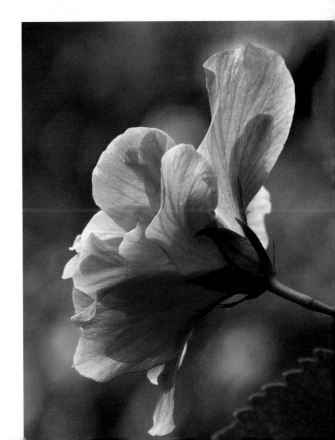

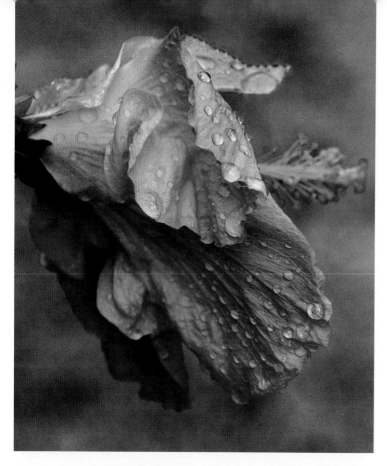

Wet Yellow Hibiscus *(top left)*

A yellow hibiscus bloom in the hibiscus garden of Bonnet House Museum & Gardens is covered with drops of water moments after a rainstorm on June 6, 2015. I used a Canon EOS 20D camera with a Canon 55–250mm lens set to a focal length of 131mm. With an ISO rating of 400, my exposure settings were $^1/_{400}$ second at f/10.

Yellow Hibiscus Close Up

(bottom left)

The sphere-shaped, pollen-packed anthers of a yellow hibiscus bloom act as a lure for insects to pollinate the blossom at Bonnet House Museum & Gardens on February 27, 2015. I used a Canon EOS 20D camera with a Sigma 17–70mm lens set to a focal length of 70mm. With an ISO rating of 1600, my exposure settings were $^1/_{800}$ second at f/16.

Wet Red Hibiscus *(facing page)*

A scarlet hibiscus bloom in the hibiscus garden of Bonnet House Museum & Gardens is covered with droplets of water after a rainstorm on May 17, 2015. I used a Canon EOS 20D camera with a Canon 55–250mm lens set to a focal length of 131mm. With an ISO rating of 400, my exposure settings were $^1/_{200}$ second at f/6.3.

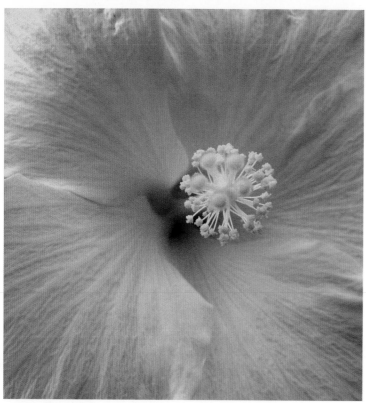

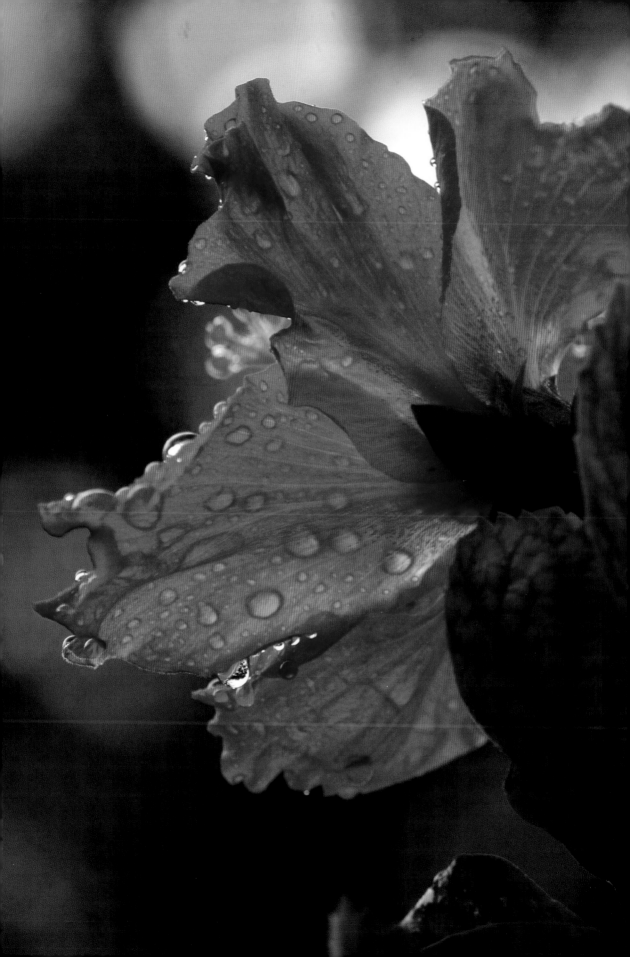

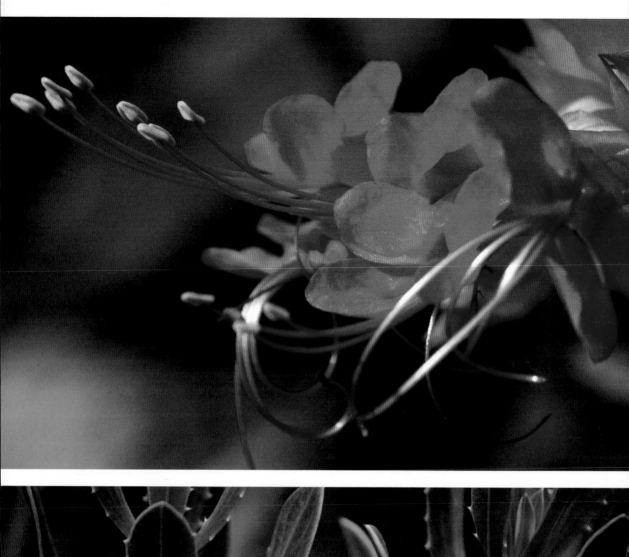

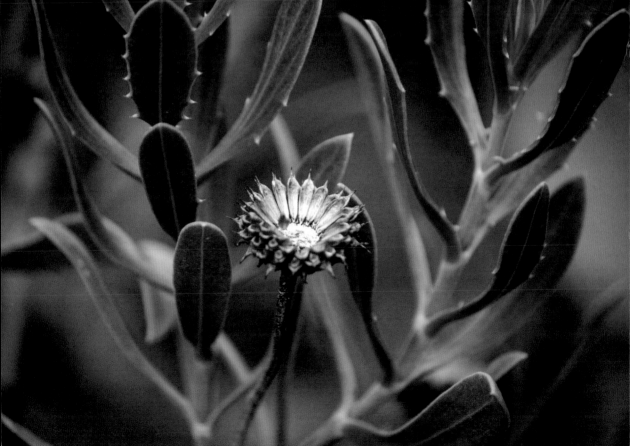

Four Tiny Red Flowers *(facing page, top)*

The yellow, oval, pollen-filled anthers extending from a cluster of four red bleeding-heart blossoms are side lit by the morning sun in front of the gift shop at Bonnet House Museum & Gardens on November 20, 2015. This image was taken with a Canon EOS 70D camera and a Canon 55–250mm lens set to a focal length of 179mm. With an ISO rating of 400, my exposure was $1/640$ second at f/8.

Aging Sunflower *(facing page, bottom)*

A single dying sunflower was photographed near the Welcome Center at Bonnet House Museum & Gardens September 24, 2015. This image was taken with a Canon EOS 40D camera and a Canon 55–250mm lens set to a focal length of 194mm. With an ISO rating of 200, my exposure was $1/500$ second at f/5.6.

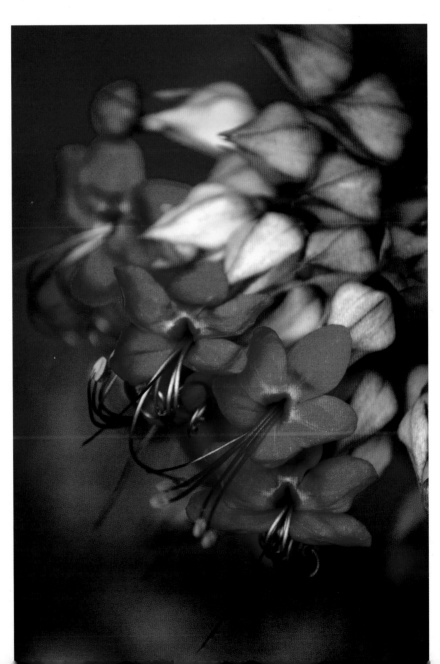

Vertical Bleeding Heart Cluster *(right)*

A cluster of red bleeding heart blossoms, glow in the morning sun, in front of the gift shop at Bonnet House Museum & Gardens on November 25, 2015. This image was taken with a Canon EOS 70D camera and a Canon 55–250mm lens set to a focal length of 229mm. With an ISO rating of 400, my exposure was $1/320$ second at f/6.3.

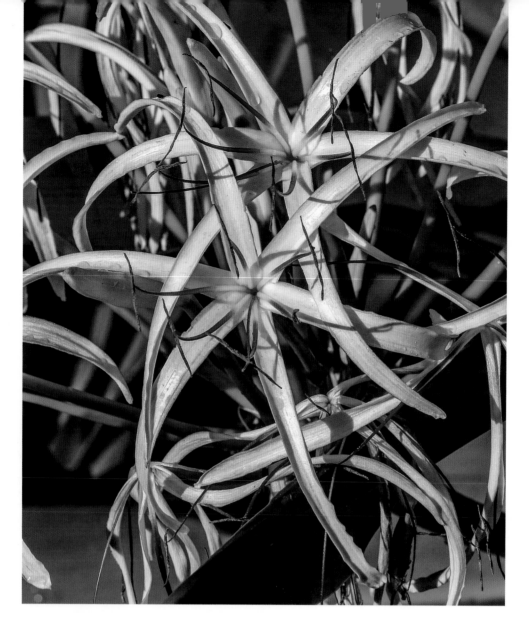

Red Crinum Flowers *(above)*

A cluster of spider-like red crinum blossoms open their slender blooms in the parking lot of Bonnet House Museum & Gardens on May 23, 2015. This image was taken with a Canon EOS 20D camera and a Canon 55–250mm lens set to a focal length of 70mm. With an ISO rating of 100, my exposure was $1/500$ second at f/10.

Two Tiny Red Flowers *(facing page)*

Two tiny red bleeding-heart blossoms glow in the morning sun in front of the gift shop at Bonnet House Museum & Gardens on October 31, 2015. This image was taken with a Canon EOS 70D camera and a Canon 55–250mm lens set to a focal length of 250mm. With an ISO rating of 400, my exposure was $1/250$ second at f/5.6.

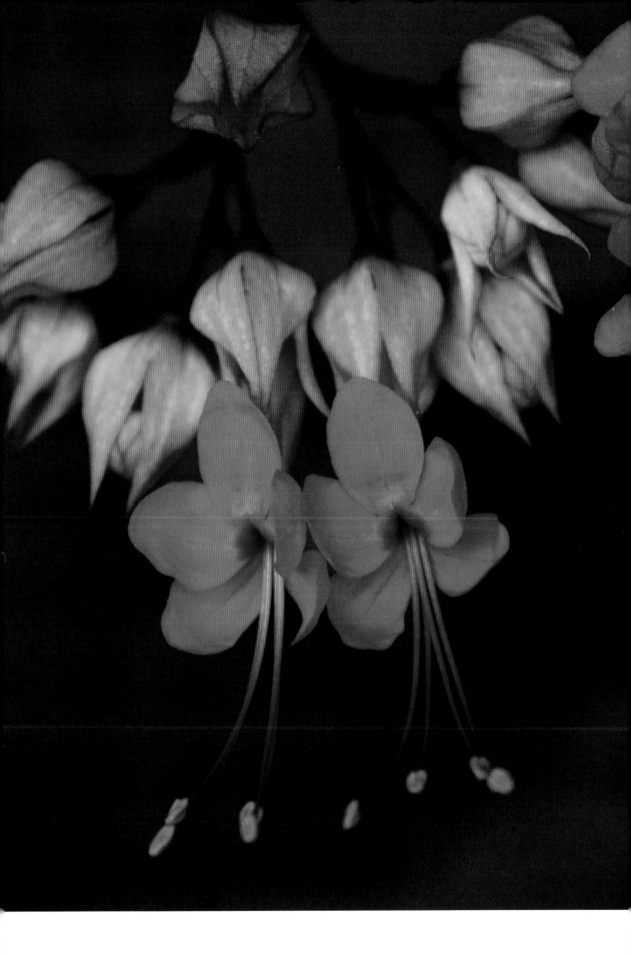

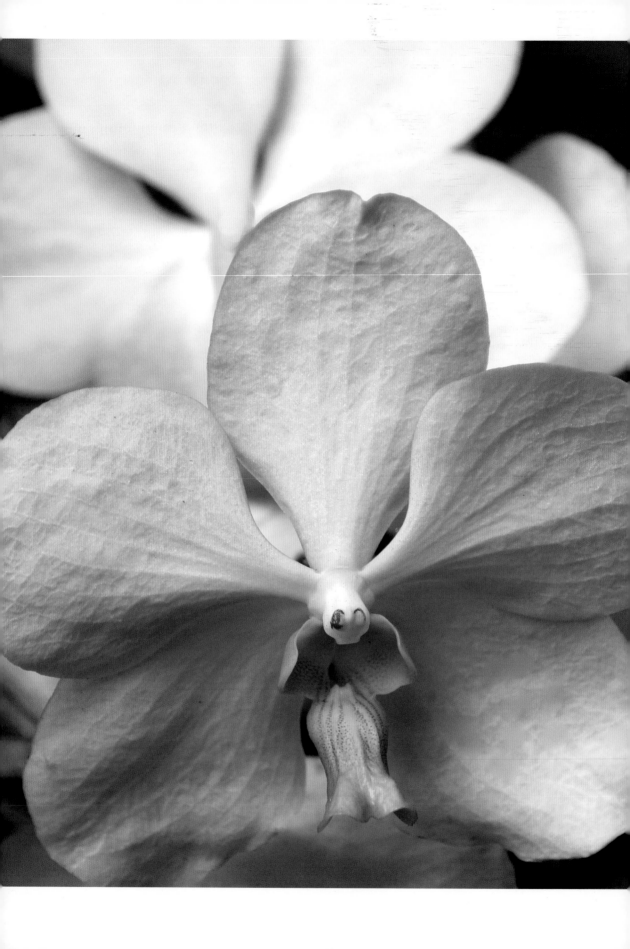

Single Bleeding Bloom

(top right)

A single red bleeding heart blossom shines in front of the gift shop at Bonnet House Museum & Gardens on October 31, 2015. This image was taken with a Canon EOS 70D camera and a Canon 55–250mm lens set to a focal length of 250mm. With an ISO rating of 400, my exposure was $^1/_{320}$ second at f/5.6.

Five Orange Orchids

(bottom right)

A cluster of five orchids bearing a resemblance to yellow parrots with brown eyes and orange wings, was photographed at Bonnet House Museum & Gardens on October 31, 2015. I used a Canon EOS 70D camera with a Canon 55–250mm lens set to a focal length of 250mm. With an ISO rating of 400, my exposure settings were $^1/_{85}$ second at f/5.6.

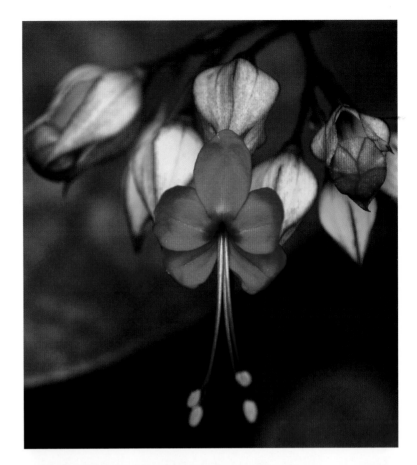

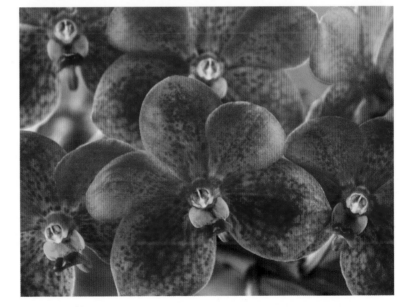

White Orchid *(facing page)*

A white, brown-eyed orchid appearing to be attired in a pink-, lavender-, and lime-colored dress, was photographed at Bonnet House Museum & Gardens on April 2, 2015. I used a Canon EOS 20D camera with a Canon 55–250mm lens set to a focal length of 105mm. With an ISO rating of 400, my exposure settings were $^1/_{640}$ second at f/6.3.

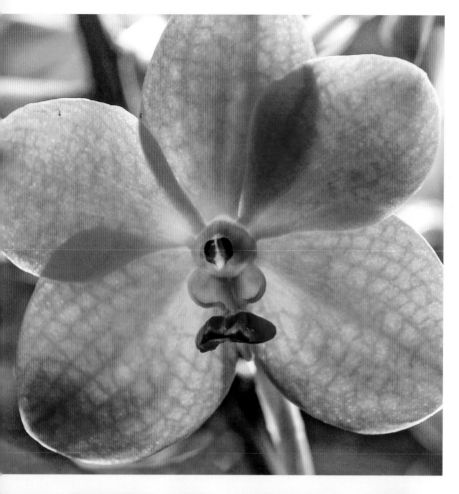

Single Orchid

(top left)

An orange orchid bloom, resembling an owl perched on a small brown branch, was photographed at Bonnet House Museum & Gardens on October 31, 2015. I used a Canon EOS 70D camera with a Canon 55–250mm lens set at a focal length of 154mm. With an ISO rating of 400, my exposure settings were $1/320$ second at f/6.3

Orange Orchids in Formation

(bottom left)

A cluster of orange orchids resembling a flock of winged creatures flying in formation was photographed at Bonnet House Museum & Gardens on May 28, 2015. These orchids are one of many varieties cultivated in one of two hot houses. I used a Canon EOS 20D camera with a Canon 55–250mm lens set at 123mm. With an ISO rating of 400, my exposure settings were $1/200$ second at f/6.3.

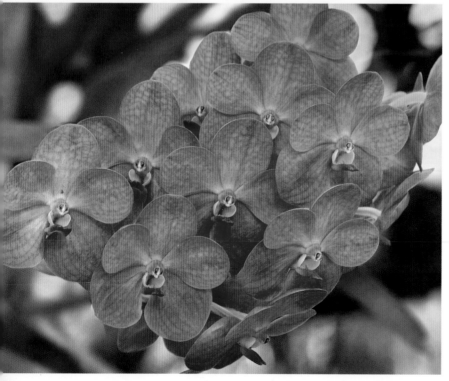

Religious Pink Orchid

A scarlet, pink, and orange orchid at Bonnet House Museum & Gardens resembles a robed monk with wings on May 17, 2015. I used a Canon EOS 20D camera with a Canon 55–250mm lens set to a focal length of 208mm. With an ISO rating of 800, my exposure settings were $\frac{1}{250}$ second at f/5.6.

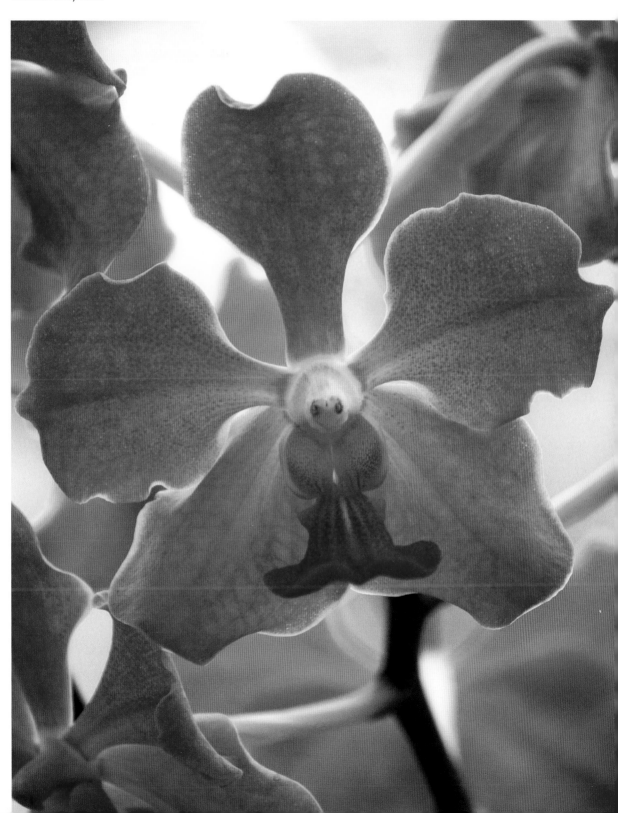

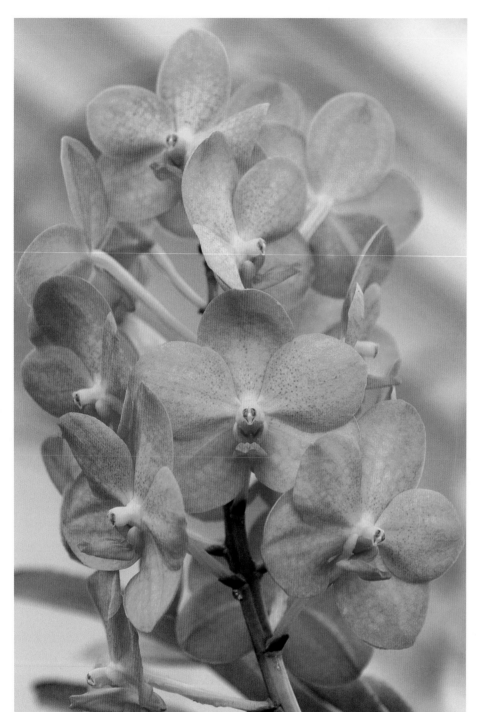

Orange Orchids

(left)

A group of orange orchids, photographed in one of two hot houses at Bonnet House Museum & Gardens on June 12, 2015, resembles yellow birds with brown eyes. I used a Canon 40D camera with Sigma 17–70mm lens set to a focal length of 70mm. With an ISO light sensitivity rating of 400, my exposure settings were $1/100$ second at f/5.6

Vertical Orange Orchid Cluster *(facing page)*

Orange orchids, with wings that resemble orange and yellow birds with brown eyes, were photographed at Bonnet House Museum & Gardens on June 12, 2015. I used a Canon 40D camera and Sigma 17–70mm lens set to a focal length of 70mm. With an ISO of 100, my exposure settings were $1/125$ second at f/9.

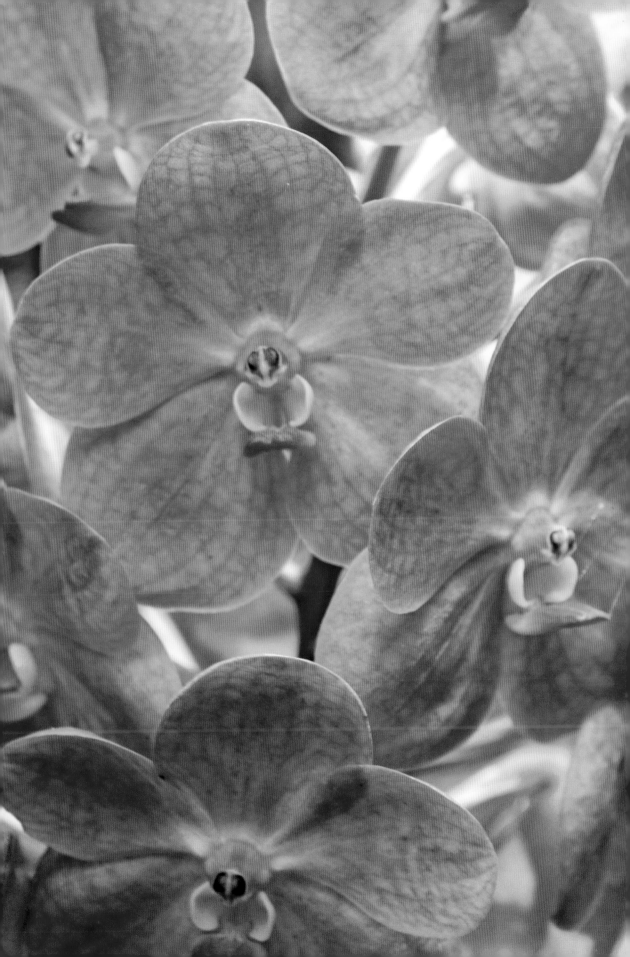

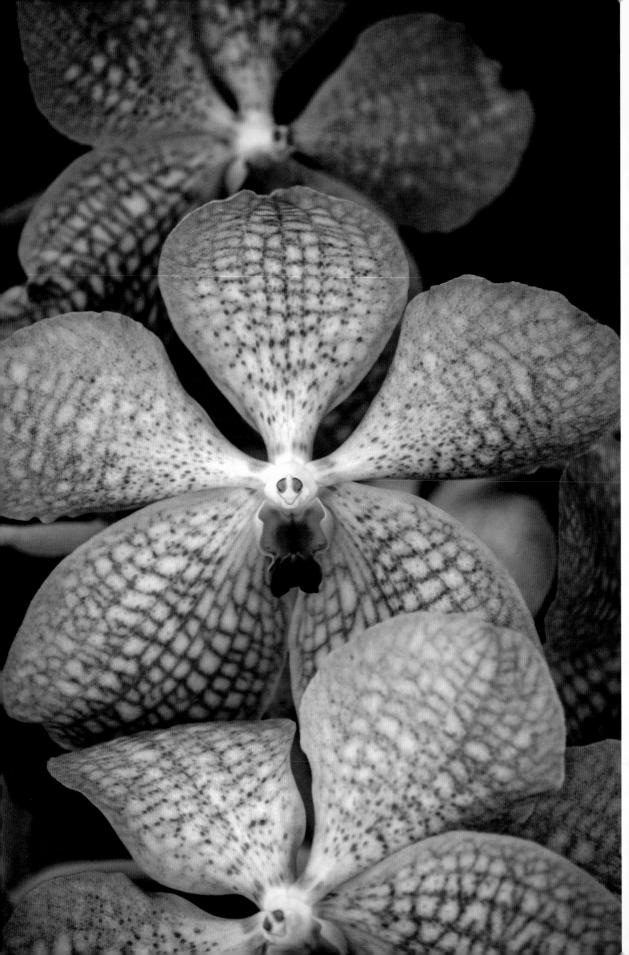

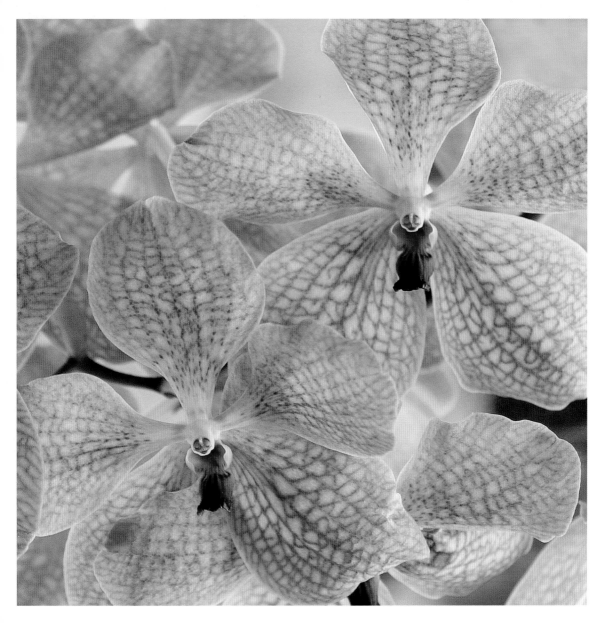

Vertical Purple Orchid (facing page)

These two orchids, with intricately patterned white wings and purple horizontal/vertical lines, appear to be smiling for their portrait at Bonnet House Museum & Gardens on June 18, 2015. I used a Canon 40D camera with Canon 55–250mm lens set to a focal length of 135mm. With an ISO light sensitivity rating of 100, my exposure settings were ¹⁄₁₀₀ second at f/5.6.

Square Purple Orchids (above)

Two strongly backlit orchid blooms were photographed at Bonnet House on March 29, 2015. I used a Canon 20D camera with Canon 55–250mm lens set to a focal length of 55mm. With an ISO light sensitivity rating of 400, my exposure settings were ¹⁄₅₀ second at f/4.

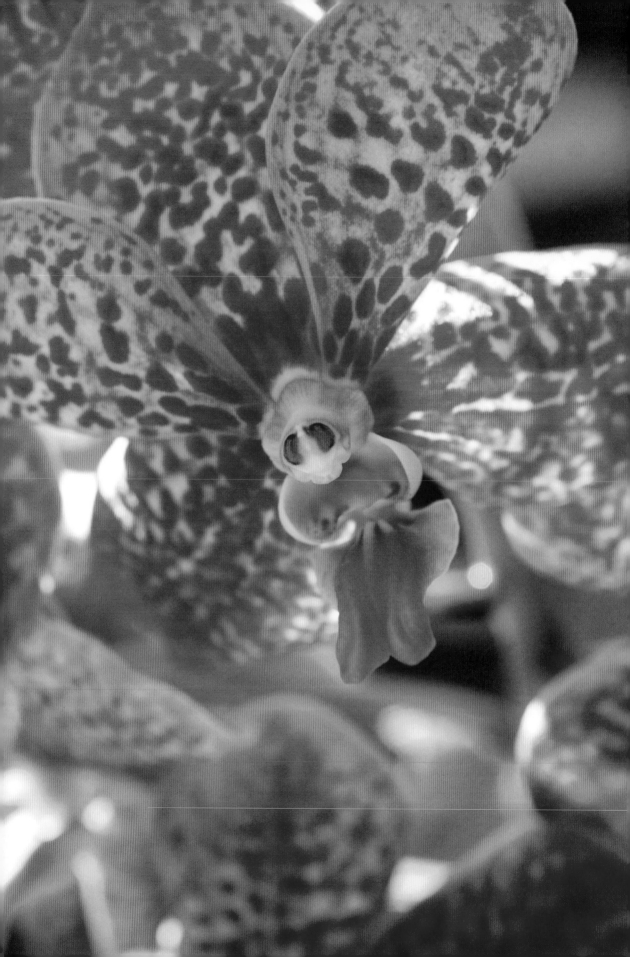

Single Backlit Monkey Orchid *(facing page)*

A backlit orchid bloom, resembling an elderly lady with pink hair, was photographed at Bonnet House Museum & Gardens on April 18, 2015. I used a Canon EOS 20D camera with Canon 55–250mm lens set to a focal length of 250mm. With an ISO light sensitivity rating of 1000, my exposure settings were $^1/_{250}$ second at f/9.

Pink and Burgundy Orchids

(right)

This group of richly saturated burgundy and lavender orchids with outstretched arms was photographed at Bonnet House, on July 2, 2015. I used a Canon 40D camera with Canon 55–250mm lens set to a focal length of 146mm. With an ISO light sensitivity rating of 400, my exposure settings were $^1/_{400}$ second at f/8.

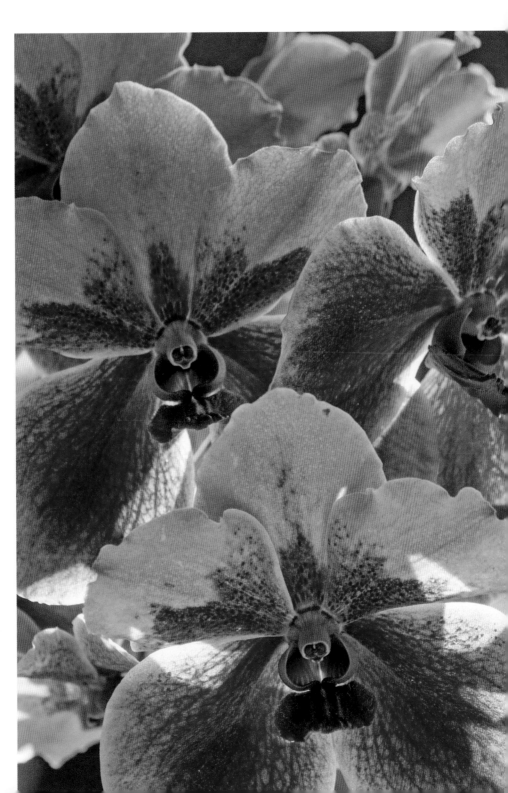

4. **Birds**

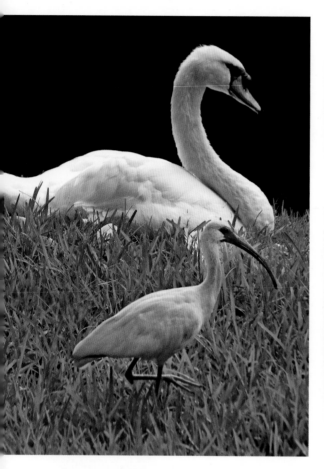

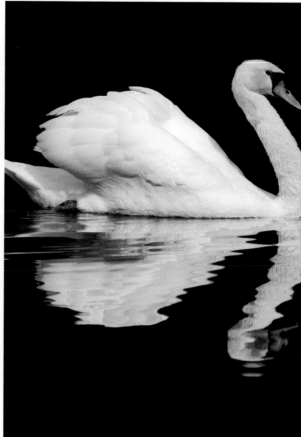

Swan and Ibis

During a swan shooting session at Bonnet House Museum & Gardens, an ibis casually strolled into and out of my picture. I love the similar shapes of their long, graceful necks. This picture was shot on June 19, 2016. I used a Canon EOS 70D camera with a Canon 55–250 lens set to194mm. At an ISO light sensitivity rating of 1600, my exposure was $^1\!/_{1000}$ second at f/10.

Regal Swan Reflection

Both of the two mute swans at Bonnet House frequently posed for me. Early one morning, the dark lily pond and white swan combined to produce excellent reflections. I tried to capture the swan's beauty and regal pride. This picture was shot on July 28, 2015. I used a Canon 40D with a Canon 55–250 lens set to 250mm. At ISO 400, my exposure was $^1\!/_{500}$ second at f/9.

Splash Landing

This picture of a swan during a thunderously loud and splashy landing on the lily pond adjacent to Bonnet House was one of the first images I shot on the 35–acre estate. It remains one of my favorites. This image was made on April 7, 2015. I used a Canon EOS 20D camera with a Sigma 17–70mm lens set to 70mm. At ISO 400, my exposure was $\frac{1}{500}$ at f/5.6.

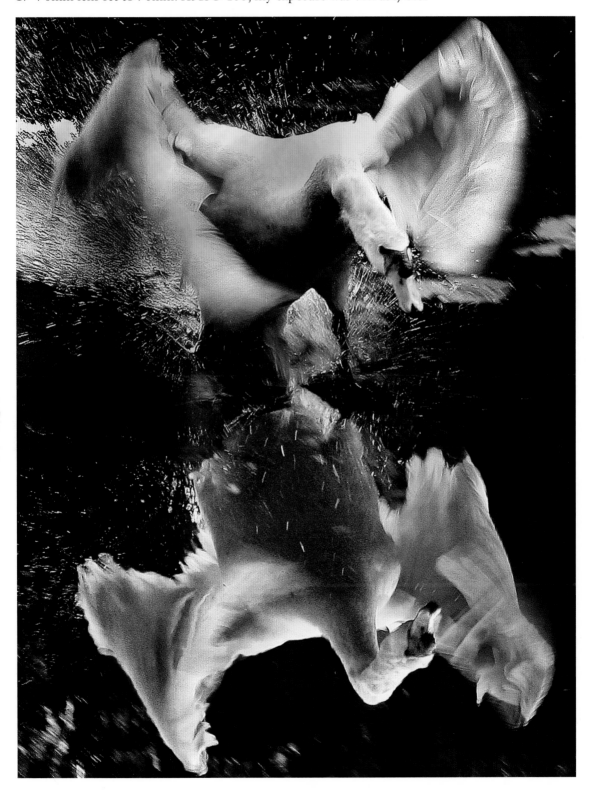

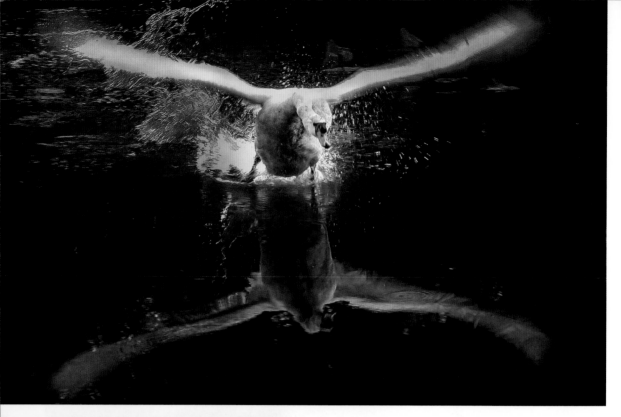

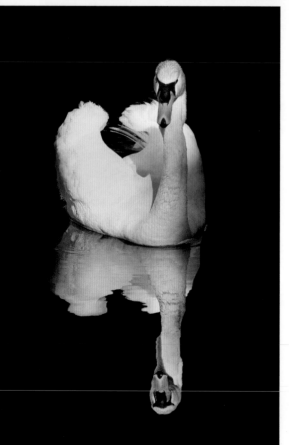

Swan Landing (above)

A male mute swan lands hot and fast on the surface of a large lily pond at Bonnet House. The roughly football field–sized slough replaces a traditional front yard at Bonnet House. The swan's touchdown was loud, rapid, and unexpected. It is one of my favorites Bonnet House pictures. This image was shot on April 7, 2015. I used a Canon EOS 20D camera with a Sigma 17–70mm lens set to 70mm. At ISO 400, my exposure was $\frac{1}{100}$ second at f/5.6.

Perfect Swan Reflection (left)

When I spotted the dignified expression on this male swan and his reflection at Bonnet House Museum & Gardens, I could not believe my good fortune. To preserve highlight details in the swan, I bracketed my exposure settings. This image was shot on March 29, 2015. I used a Canon EOS 20D camera with a Canon 55–250mm lens set to 131mm. At ISO 400, my exposure was $\frac{1}{500}$ second at f/10.

Art Swan

On one of my early trips to Bonnet House, one of the swans paddled in my direction and then swam in slow circles through the surrealistic reflection of palm trees on the dark water of the large lily pond. This image was shot on April 7, 2015. I used a Canon EOS 20D camera with a Sigma 17–70mm lens set to 70mm. At ISO 400, my exposure was $^1/_{200}$ second at f/8.

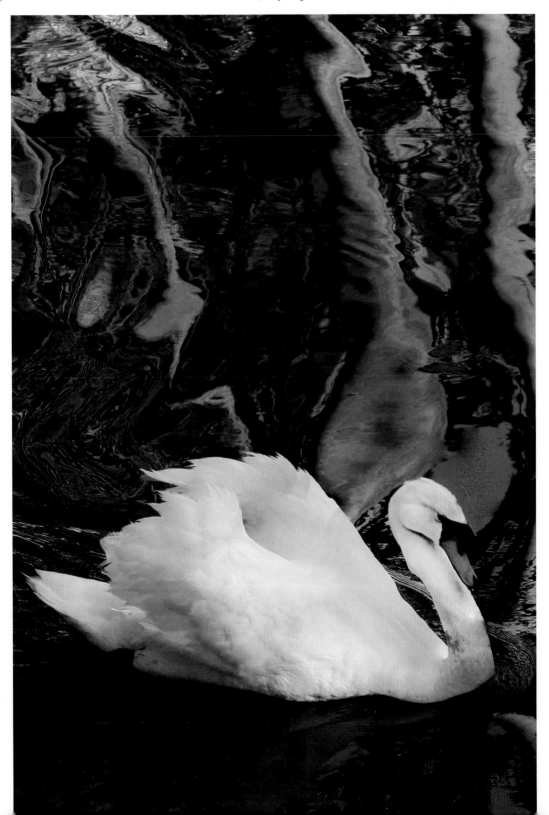

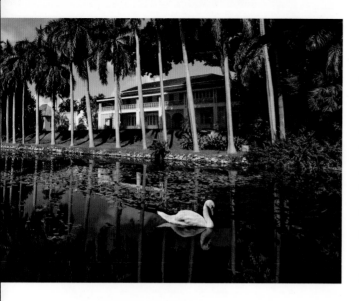

Front Views of Bonnet House and Swan *(left and facing page)*

While resting momentarily in the welcome shade of the Chickee Bridge and recovering from the oppressive heat, I saw one of the mute swans paddling slowly in front of Bonnet House. I shot several exposures. This view was my favorite. These images were shot on June 25, 2015. I used a Canon 20D with a wide angle Canon 10–18mm lens set to 10mm. At ISO 400, my exposure was $\frac{1}{400}$ second at f/16.

Reflection of Elegance *(below)*

While shooting at Bonnet House Museum & Gardens, there were moments when the light transformed the scene into a classic Dutch painting. This mute swan, admiring himself, was photographed on June 7, 2015. I used a Canon EOS 40D with a Canon 55–250mm lens, set to at109mm. At ISO 100, my exposure was $\frac{1}{60}$ second at f/5.6.

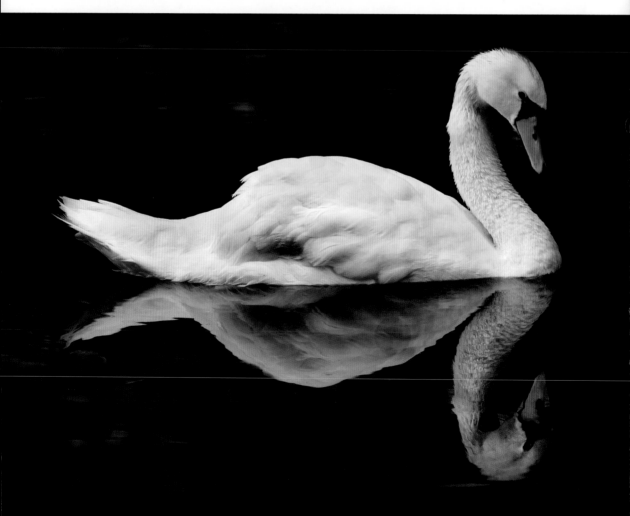

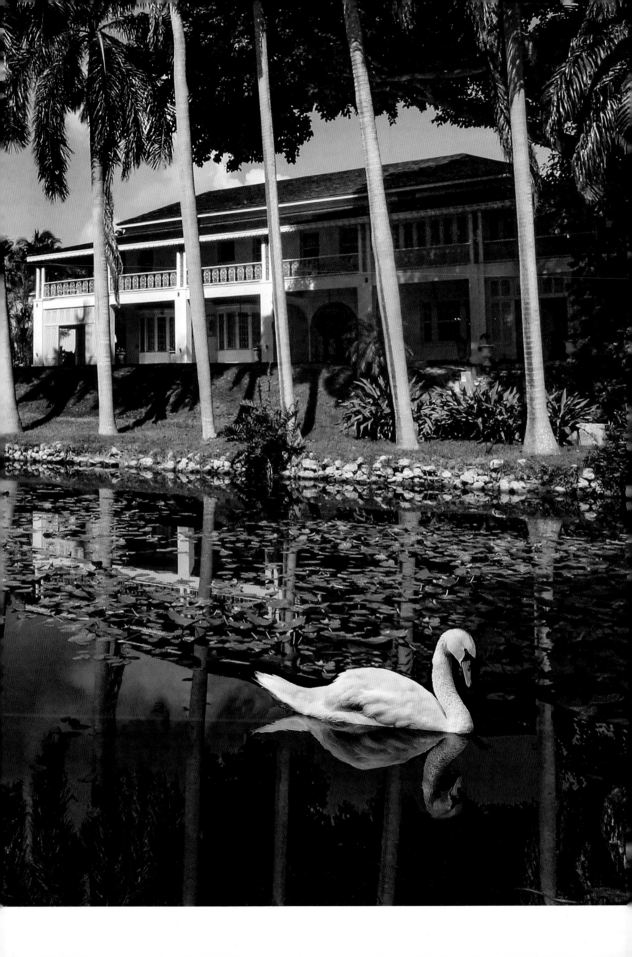

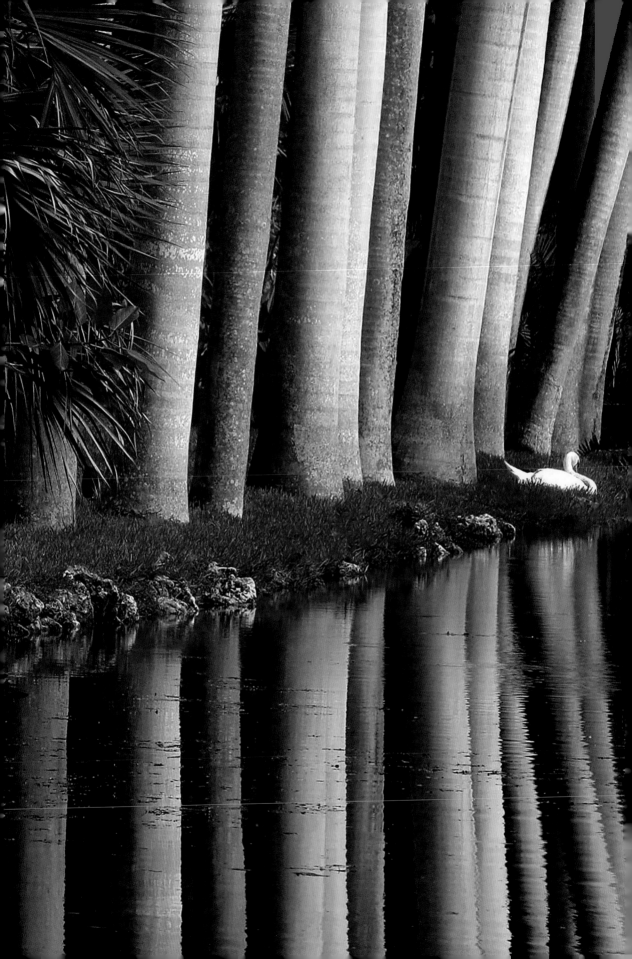

Swan and Palm Trees *(facing page)*

Sitting on a stone bench at the south end of the large lily pond one morning, I watched as one of the resident mute swans swam across the pond adjacent to Bonnet House, climbed up on the grass and sat next to a row of tall palm trees, which were reflected in the pond. This picture was shot December 20, 2015. I used a Canon EOS 70 camera with a Canon 55–250 lens set to 135 mm. At ISO 200, my exposure was $1/320$ second at f/8.

Swan Leaning Forward *(top right)*

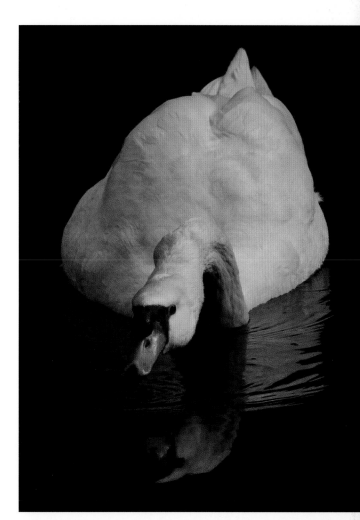

Swans, I have learned during my time at Bonnet House, feed by gathering a beak full of water and filtering out the small fish, frogs, and tadpoles. This swan was enjoying breakfast. This picture was taken on December 20, 2015, with a Canon 70D Camera and a Canon 55–200mm lens set at 200mm. At ISO 1600, my exposure was $1/1300$ second at f/11.

Swan in Reflected Reeds *(bottom right)*

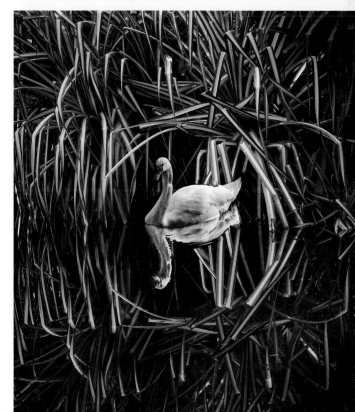

At varying times every morning, a clump of reeds on the southeast bank of the lily pond, is perfectly reflected on the dark pond water. While trying to capture the graphic composition, one of the mute swans slowly paddled into the center of my frame. This picture was taken on January 30, 2016, with a Canon EOS 70D camera and a Canon 55–250mm lens set to a focal length of 109mm. With an ISO of 1600, my exposure settings were $1/500$ second at f/9.

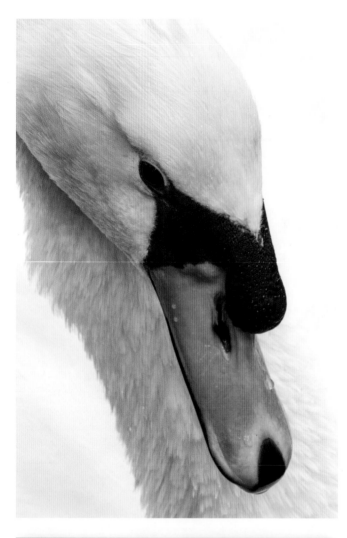

White on White Swan
Portrait *(top left)*

During a fall photo safari to Bonnet House, one of the mute swans began to execute a series of graceful, photogenic poses as I walked toward him. This image shows a bit of his confident personality and indomitable attitude. I took this picture on September 12, 2015, with a Canon EOS 40D camera and a Canon 55–250mm lens set to 250mm. My exposure, with an ISO of 400, was $1/60$ second at f/13.

Swan and Anhinga *(bottom left)*

When this mute swan, which was enjoying a solitary seafood breakfast about 50 feet away, saw me taking pictures of the anhinga, it immediately began swimming toward me to join the party. I only had to wait for the big bird to hit the right spot. This picture was taken on December 2, 2016, with a Canon EOS 70D camera and a Canon 55–250mm lens at 135mm. Using an ISO of 1600, I shot at $1/500$ second and f/10.

Extreme Swan Close-Up *(facing page)*

I was walking toward a mute swan, as it groomed the tip of its beak, when it stopped and stared at me. After I snapped off a few exposures, it lost interest—but not before I got this image. This picture was made on July 11, 2015, with a Canon EOS 40D camera and a Canon 55–150mm lens set to a focal length of 250mm. With a sensitivity rating of ISO 400, my exposure settings were $1/500$ second at f/8.

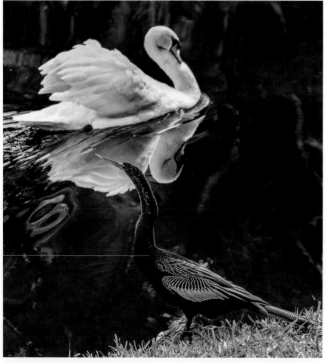

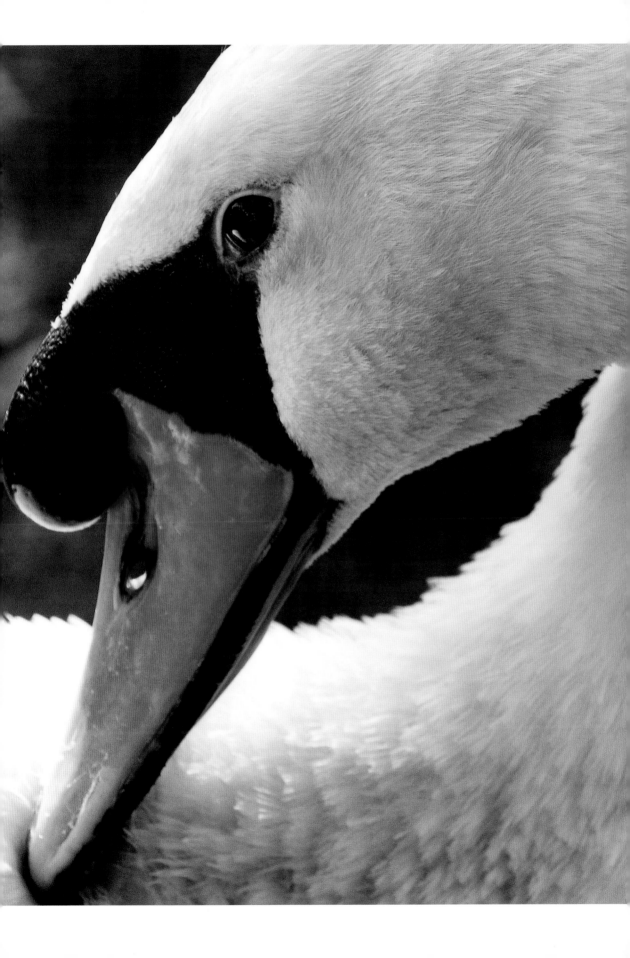

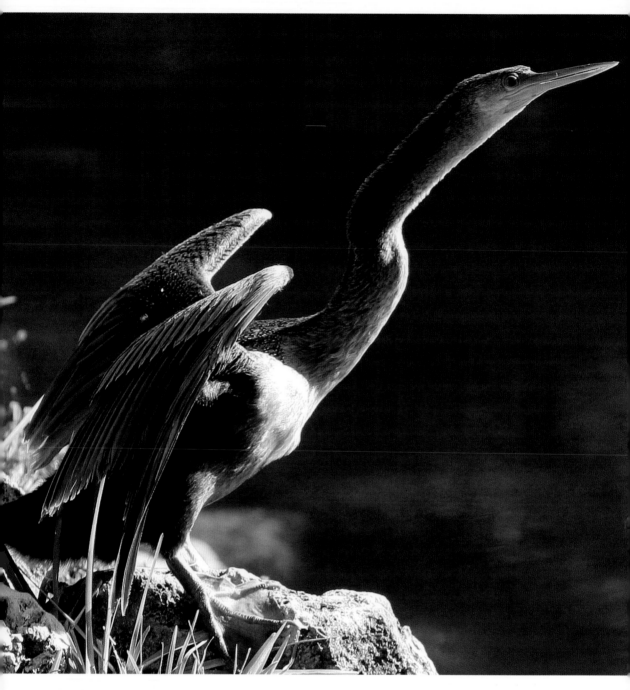

Anhinga Near Big Pond

Because a variety of Anhinga regularly visited Bonnet House, I tried to capture each as differently as possible. This is one of my favorite full-length side portraits of a bird that had nowhere to go until his wings were dry enough to fly. This picture was taken on March 31, 2015, with a Canon EOS 20D camera and a Tokina 50–135mm lens set to a focal length of 135mm. With an ISO of 400, my exposure was $^1/_{500}$ second at f/5.6.

Swan Close-Up Portrait (right)

This image comes close to capturing the hostile energy behind the angry glaring stare flashed at me by one of the mute swans when I momentarily stopped taking his picture. A few seconds later he began to mellow when he realized I was again capturing his beauty for posterity. This picture was taken July 28, 2015, with a Canon EOS 40D camera and a Canon 55–250mm lens set to a focal length of 208mm. My exposure settings were $^1/_{1000}$ second at f/11.

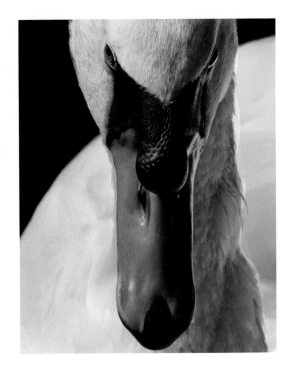

Swan Perfect Heart (below)

While walking next to the lily pond one morning, one of the mute swans began gathering small fish and tadpoles for breakfast. I shot at least a dozen images trying to time my shot with the brief creation of a reflected heart. I wish the heart were properly oriented instead of on its side. This picture was taken on July 7, 2015, with a Canon EOS 40D camera and a Canon 55–250mm lens set to a focal length of 116mm. With an ISO of 100, my exposure was $^1/_{60}$ second at f/5.6.

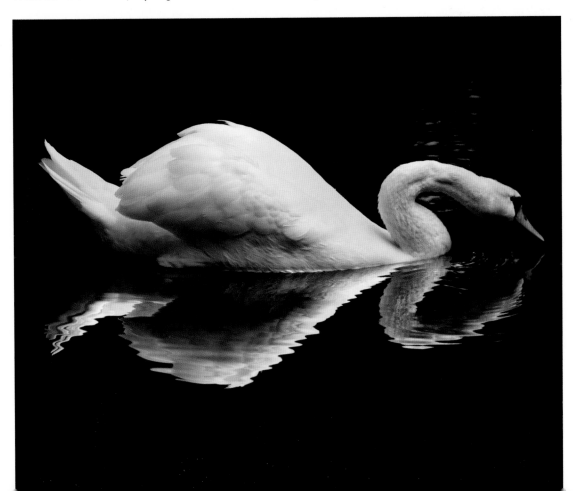

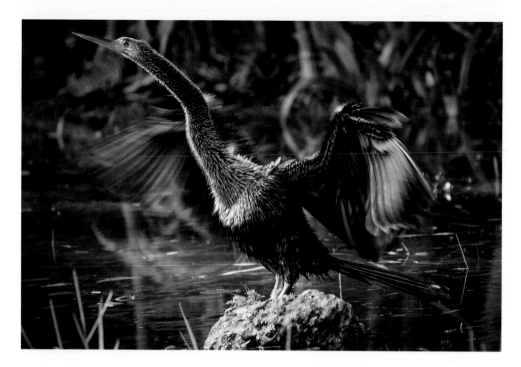

Air Drying *(above)*

Early one morning, while sitting on a shady bench next to a small lily pond at Bonnet House, an anhinga was diving for breakfast and made its way ashore to dry its fully extended wet wings about 75 feet from where I sat. It was the perfect opportunity. This is my favorite profile shot of it proactively air-drying its soggy feathers. On September 29, 2015, I used a Canon EOS 40D camera and a Canon 55–250mm lens set to a focal length of 250mm. With an ISO of 200, my exposure was $1/60$ second at f/5.6.

I Don't Do "Smile" *(right)*

An anhinga with red eyes poses for a three-quarters, head-and-shoulders portrait, while waiting for his damp feathers to dry. This picture was taken February 3, 2016, with a Canon EOS 70D and a Canon 55–250mm lens set to a focal length of 250mm. With my camera set to an ISO of 1600, my exposure was $1/640$ second at f/8.

Anhinga *(facing page)*

This three-quarters, head-and-shoulders portrait of what appears to be a pleasantly amused anhinga, was taken on March 25, 2016, with an Canon EOS 70D camera and a Canon 55–250mm lens set to a focal length of 240mm. With an ISO of 1600 my exposure was $1/500$ second at f/8.

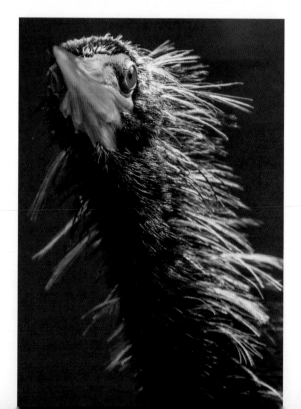

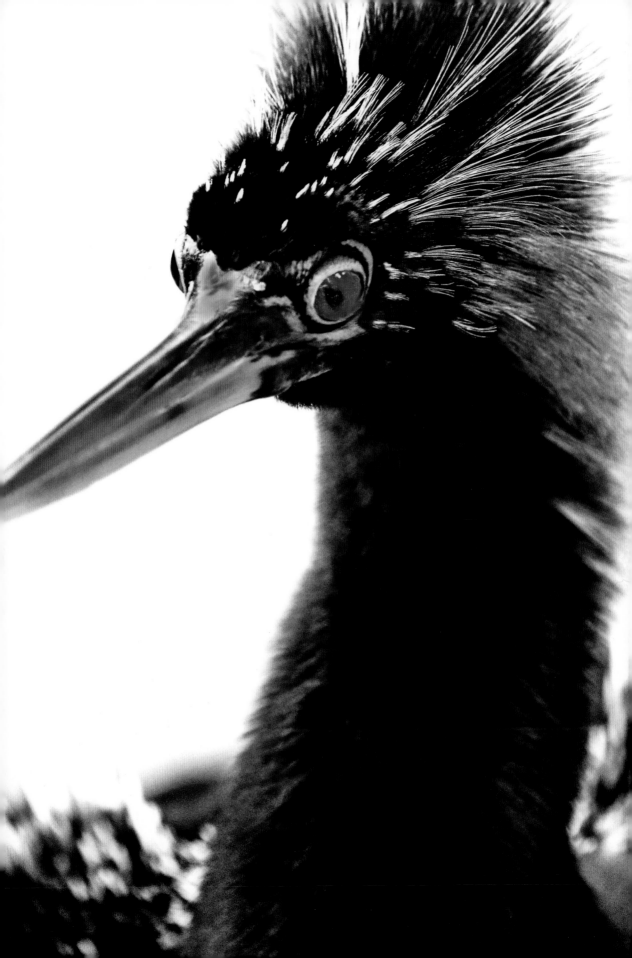

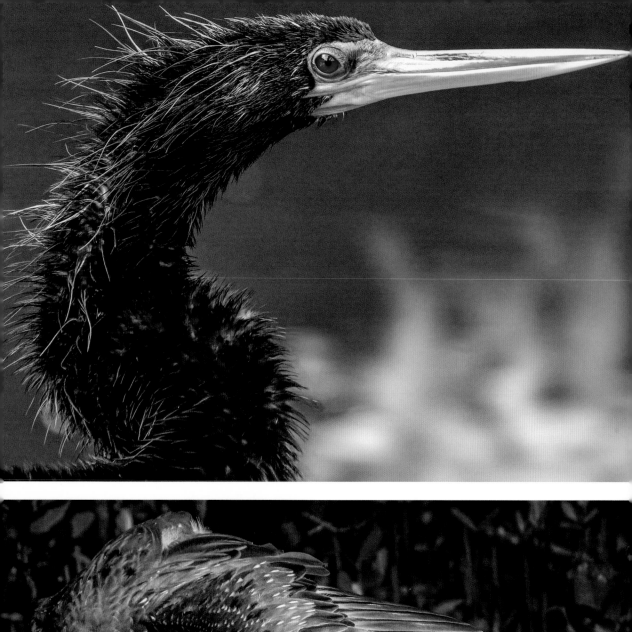
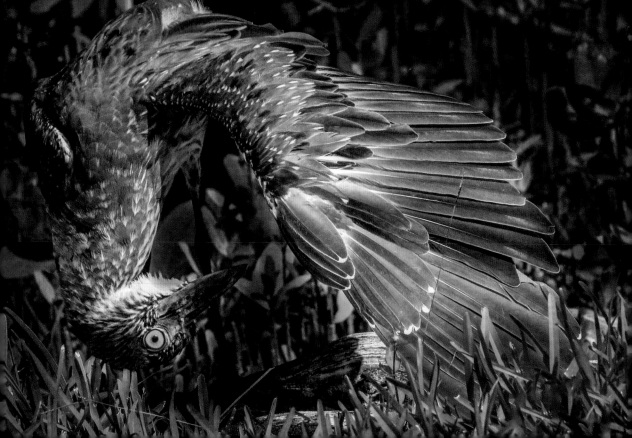

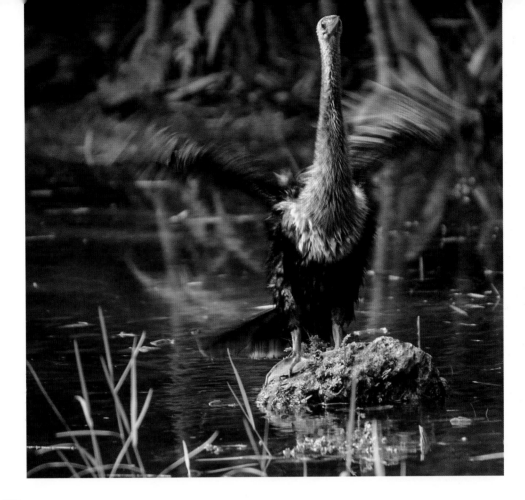

Drying Off *(facing page, top)*

When I first saw this still-damp anhinga drying out in the morning sun, its red eyes were hypnotic. This portrait was taken on February 3, 2016, with a Canon EOS 70D 55 and a Canon 55–250mm lens set to a focal length of 250mm. Using an ISO of 1600, my exposure was $^1/_{400}$ second at f/7.1.

Juvenile Yellow-Crowned Night-Heron *(facing page, bottom)*

After beginning to take pictures of a large bird standing near a swampy area adjacent to the Bonnet House parking lot, this juvenile yellow-crowned night-heron quickly struck a pose, turning its entire body, aside from its legs and feet, upside down. I'm still not certain if it was trying to get my attention or make itself invisible. The picture was taken June 18, 2016, with a Canon EOS 70D camera and a Canon 55–250mm lens, set to a focal length of 200mm. Using an ISO of 1600, my exposure was $^1/_{2000}$ second at f/16.

Just Winging It *(above)*

On September 29, 2015, while sitting next to a small lily pond, I shot this anhinga actively drying its wet feathers. I used a Canon EOS 40D camera and a Canon 55–250mm lens set to a focal length of 250mm. With an ISO of 200, my exposure was $^1/_{50}$ second at f/5.6.

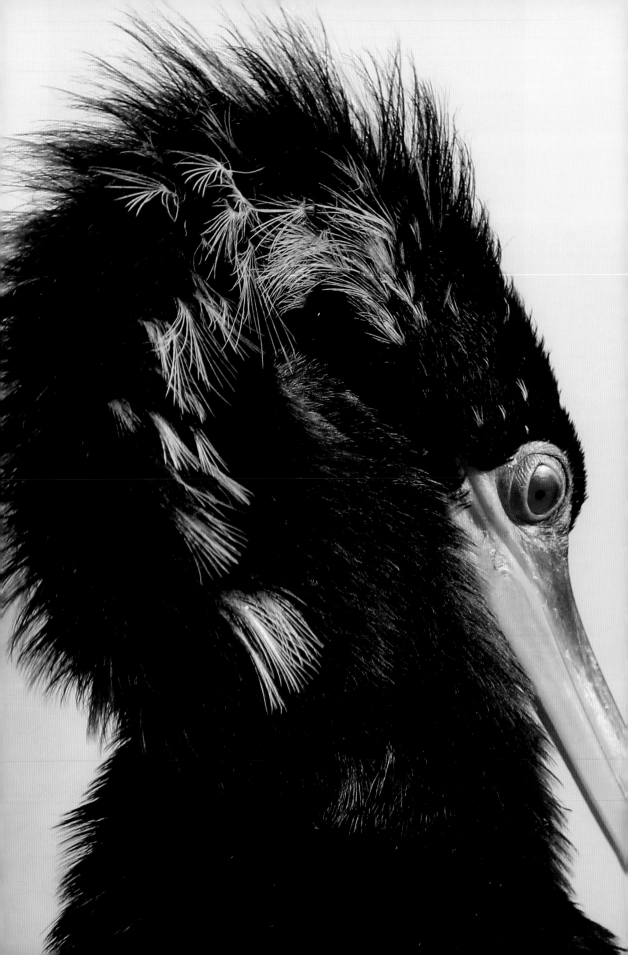

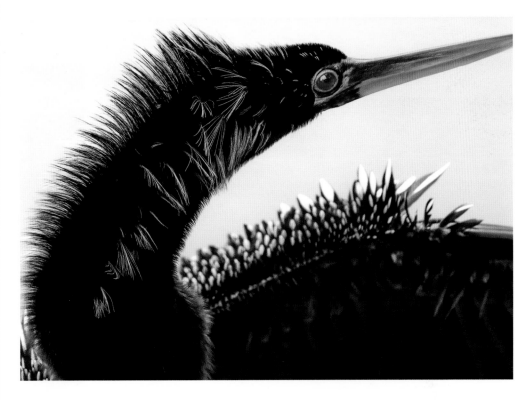

Red Eyes

These portraits of red-eyed anhingas were taken on January 30, 2016, with a Canon EOS 70D camera and a Canon 55–250mm lens set to a focal length of 250mm (left) and 187mm (above). Using an ISO of 1600, my exposure was $^1/_{640}$ second at f/9. Another image featuring the anhinga's captivating red eye appears below.

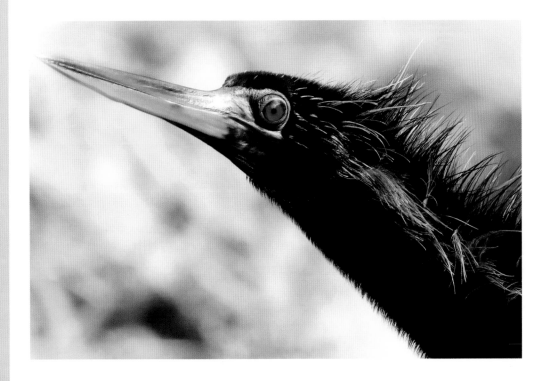

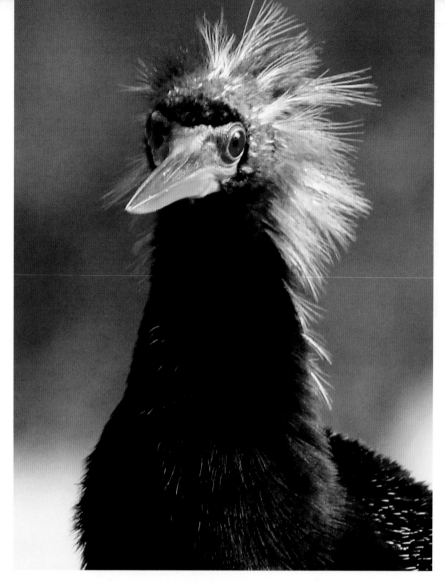

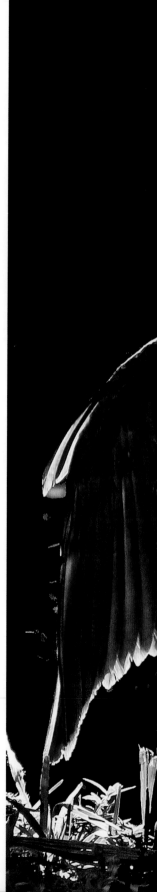

Three-Quarters Anhinga Portrait *(above)*

This head-and-shoulders anhinga portrait was taken next to the large Bonnet House lily pond on January 30, 2016. I used a Canon EOS 70D camera with a Canon 55–250mm lens set to a focal length of 171mm. Using an ISO of 1600, my exposure settings were $^1/_{800}$ at f/9.

Anhinga Drying Wings *(right)*

This picture of a backlit anhinga drying its wings, was one of the first of a number of anhinga pictures I would take over 18 months at Bonnet House Museum & Gardens. This image was made on March 29, 2015, with a Canon EOS 20D camera and a 55–250mm lens set to a focal length of 250mm. With an ISO of 400, my exposure was $^1/_{400}$ second at f/7.1.

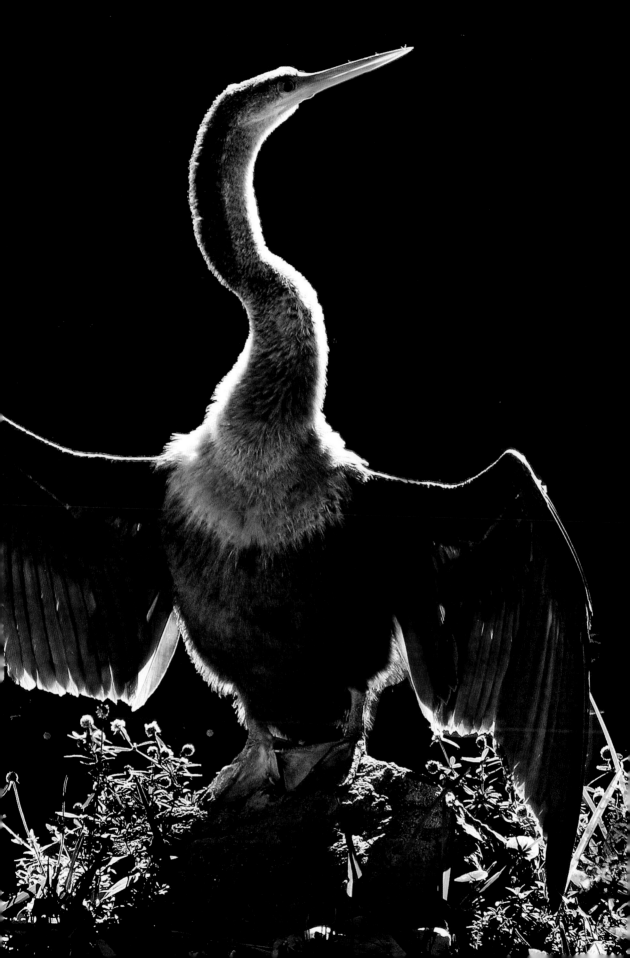

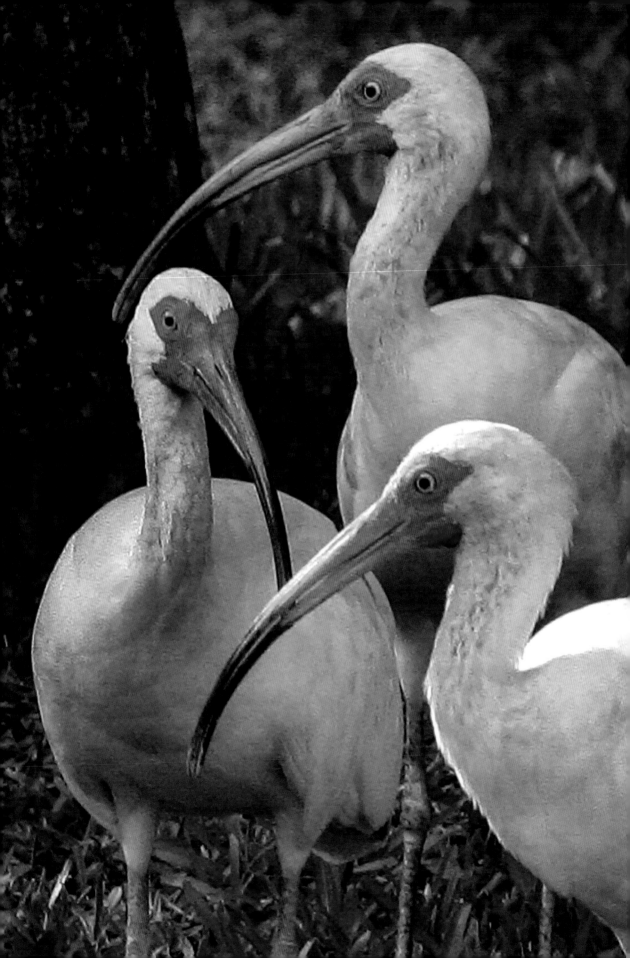

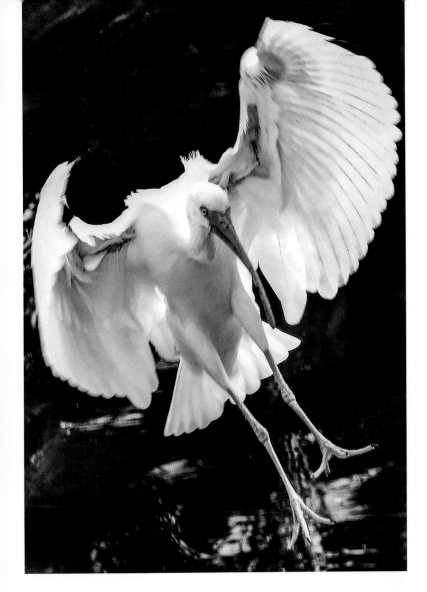

Ibis Album Cover (left)

After a flock of about a dozen ibises landed at one end of the primary Bonnet House lily pond, three of the large white birds formed a small group. To me, they looked like members of a three-ibis rock-and-roll band called The White Birds, posing for their album *Birds of a Feather*. This picture was taken on June 21, 2015, with a Canon EOS 20 D camera and a Sigma 50–500mm lens set to a focal length of 313mm. With an ISO of 1600, my exposure was $1/6400$ second at f/9.

Big Guns (above)

While coming in for a landing, an ibis inadvertently reveals what it has been hiding under its wing feathers. This picture was shot on the morning of January 11, 2016, with a Canon EOS 70D camera set to a focal length of 250mm. Using an ISO of 1600, my exposure was $1/1250$ second at f/11.

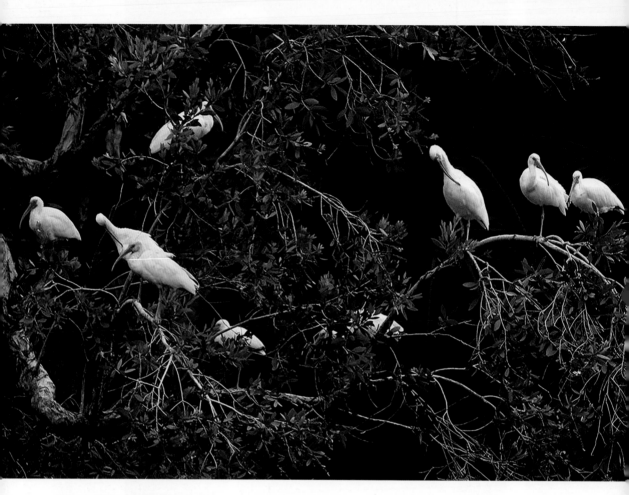

Nine Birds, Nine Beaks *(above)*

After watching these nine ibises land in a tree, it took nearly a half hour for the birds (which were all busy burying their faces in their feathers) to stop grooming themselves. I finally got to see all of their faces at one time and the chance to get one good shot. This picture was taken on February 2, 2016, with a Canon EOS 70D camera and a Canon 55–250mm lens set to a focal length of 250mm. With an ISO of 400, my exposure was $^1/_{250}$ second at f/11.

Balancing Act *(facing page)*

Not only did this ibis look directly at the camera with one blue eye while perfectly balanced on one thin leg, but it did so in front of a non-distracting background. This image was captured on June 28, 2015, with a Canon EOS 20D camera and a Canon 55–250mm lens set to a focal length of 250mm. Using an ISO of 400, my exposure was $^1/_{400}$ second at f/7.1.

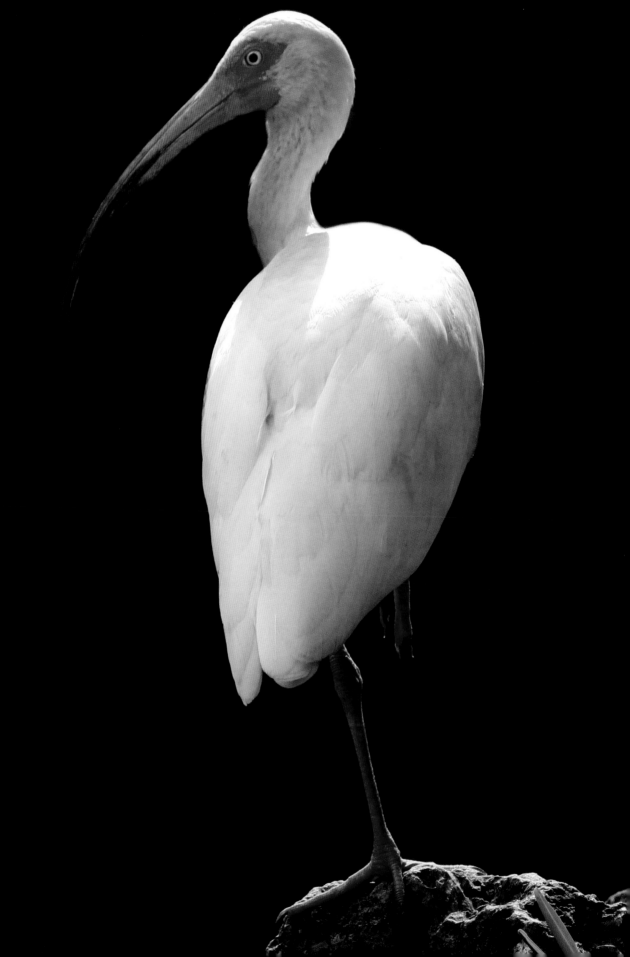

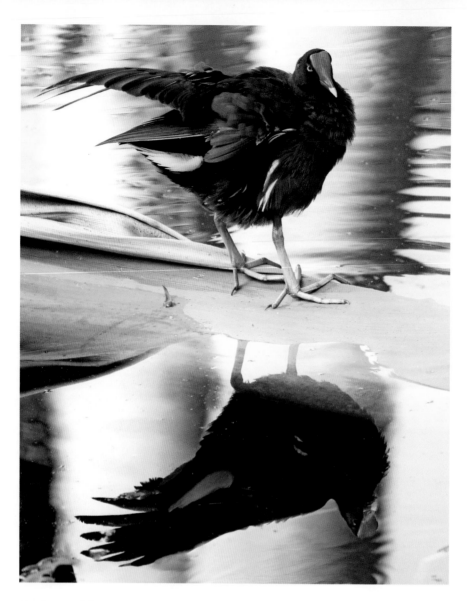

Common Moorhen on Palm Frond (above)

A common moorhen, decorated with a distinctive red head stripe, is reflected in the water of a lily pond adjacent to Bonnet House while resting on a partially submerged palm frond. This picture was taken on July 1, 2015, with a Canon EOS 20D camera with a 55–250mm lens set to a focal length of 250mm. My exposure settings, with an ISO of 400, was $\frac{1}{250}$ second at f/5.6.

Great Blue Heron (facing page)

A great blue heron, brightly illuminated by direct morning sunlight, stands on the bank of a lily pond and searches for a seafood breakfast at Bonnet House Museum & Gardens. This picture was shot on January 30, 2016, with a Canon 70D camera and a Canon 55–250mm lens set to a focal length of 250mm. At ISO 1600, my exposure was $\frac{1}{1000}$ second at f/11.

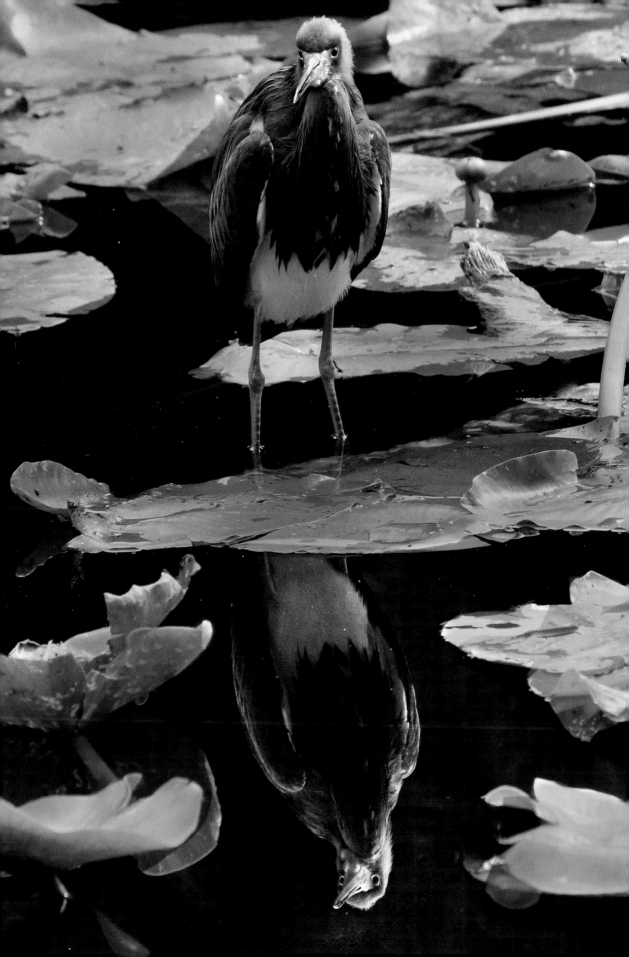

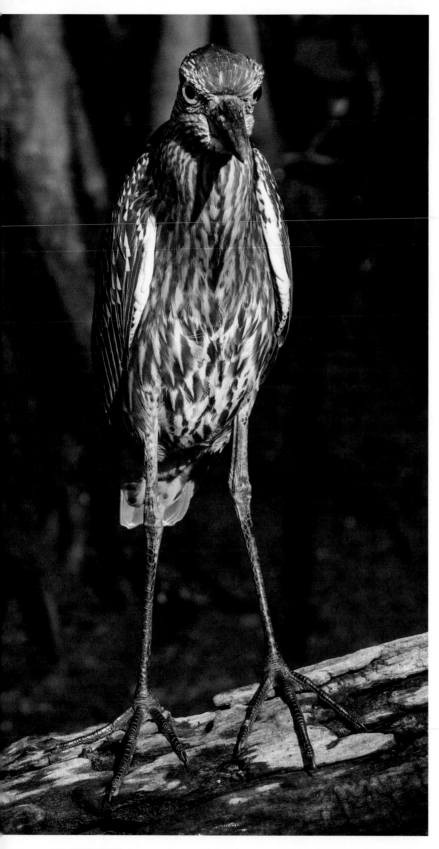

Juvenile Yellow-Crowned Night-Heron on Alert

(left)

The facial expression of a juvenile yellow-crowned night-heron indicates its disposition while attempting to spot a seafood breakfast. The bird was perched on a limb extending over the water of a mangrove swamp near the parking lot of Bonnet House Museum & Gardens. This picture was taken on June 18, 2016, with a Canon EOS 70D camera and a Canon 55–250mm lens set to a focal length of 220 mm. At ISO 400, my exposure was $1/800$ at f/10.

Juvenile Yellow-Crowned Night-Heron *(facing page)*

This close-up picture of a juvenile yellow-crowned night-heron at Bonnet House Museum & Gardens, reveals its colorful feathers. This picture was taken on June 18, 2016, with a Canon EOS 70D camera and a Canon 55–250mm lens set to a focal length of 250mm. At ISO 1600 my exposure was $1/1600$ second at f/14.

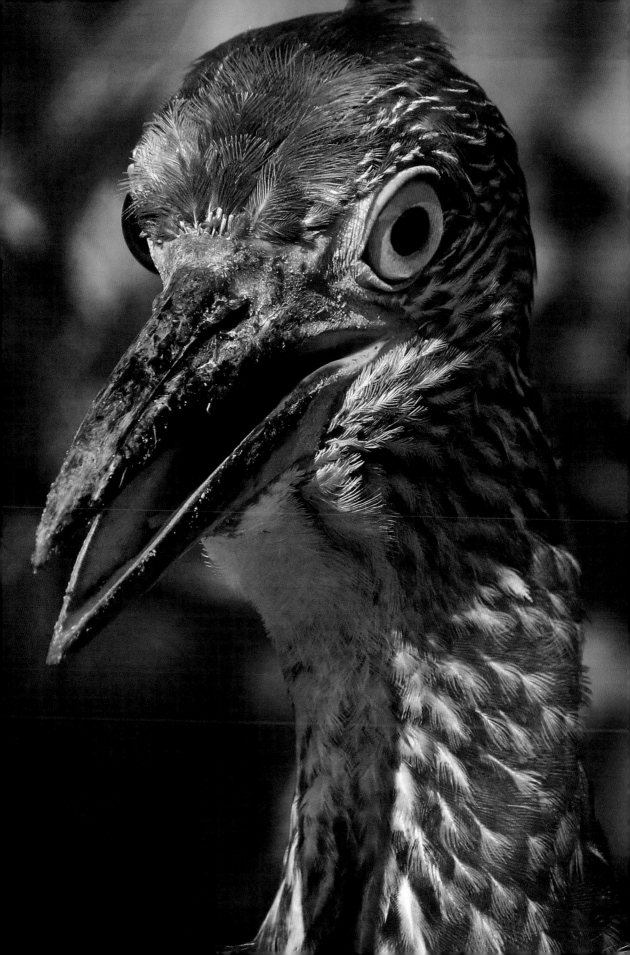

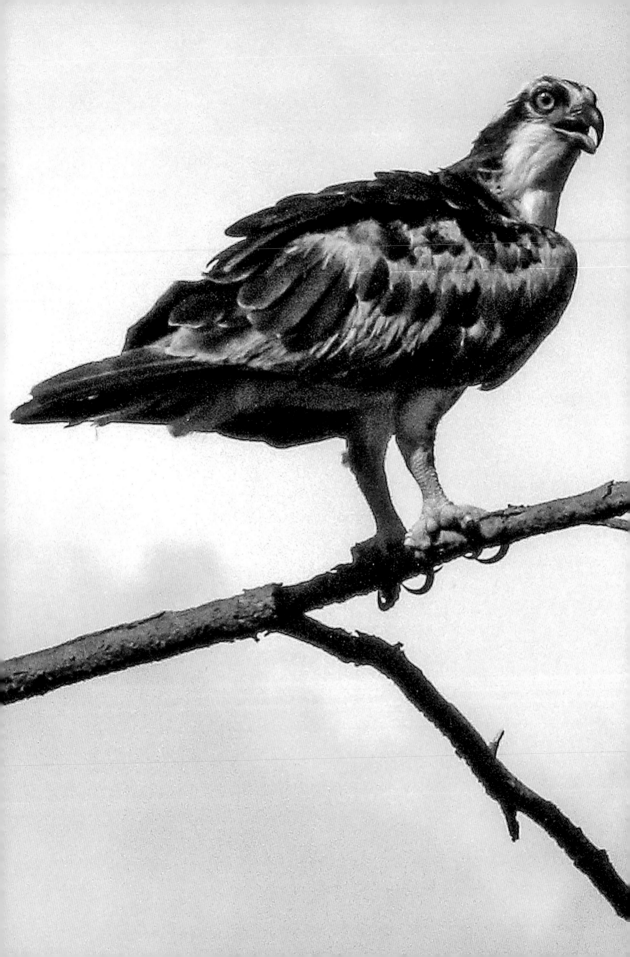

Hawk on Tree Branch *(facing page)*

On the morning of June 29, 2016, while returning to my car after a sweat-drenching visit to Bonnet House Museum & Gardens, I watched as a bird I had not seen at the estate before, landed on a bare tree limb. I shot this hawk's full-length portrait, with a Canon EOS 70D camera and a Canon 55–250mm lens set to a focal length of 250mm. With an ISO setting of 1600, my exposure was $1/4000$ second at f/20.

Yellow Eye Glowing *(top right)*

On May 15, 2015, I noticed a female green heron with glowing yellow eyes and red/gold plumage, wading in the shade near the shore of a small Bonnet House lily pond. When a shaft of sunlight broke through the clouds and illuminated it, I shot this image with a Canon 70D camera and a Sigma 50–500mm lens set at a focal length of 266mm. Using an ISO of 1600, my exposure settings were $1/100$ second at f/11.

Male Cardinal *(bottom right)*

I have long felt that when a wild animal desires to have its picture taken, I should oblige gratefully. This full-length portrait of a male cardinal, which chose to pose in front of a distraction-free background, was shot the day after Christmas in 2015. I used a Canon EOS 70D camera with a Canon 55–250mm lens, set to a focal length of 116mm. My exposure settings, at ISO 1600, were $1/400$ second at f/9.

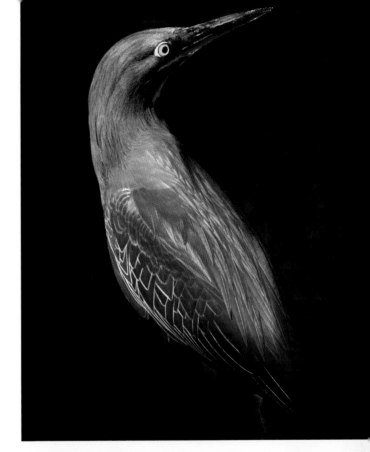

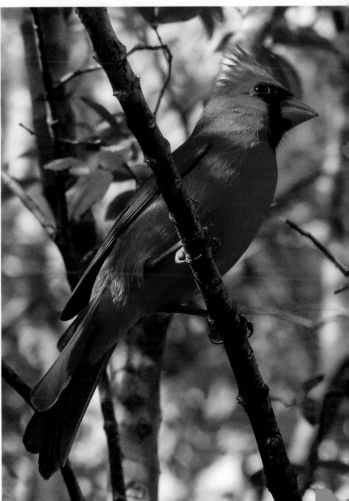

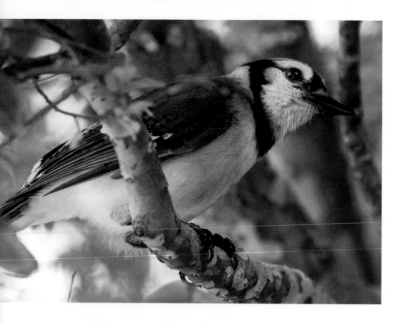

Bluejay (left)

On the morning of March 25, 2016, while searching for any of the three Bonnet House monkeys, a blue jay landed a few feet from where I stood. After giving me an opportunity to shoot only one full-length portrait, he disappeared. This picture was taken with a Canon EOS 70D camera and a Canon 55–250mm lens set to a focal length of 250mm. At ISO 1600, my exposure was $^1/_{4000}$ second at f/7.1.

Two Birds with Yellow Legs (below)

On the morning of June 19, 2016, I waited with above-normal patience, for two female moorhens standing on a partially submerged tree branch with their backs to me, to turn around and face in my direction. When they eventually pivoted just enough for me to see their faces in profile, I got the shot I was waiting for. I used a Canon 70D camera and a Canon 55–250mm lens set to a focal length of 250mm. At ISO 1600, my exposure settings were $^1/_{320}$ second at f/6.3.

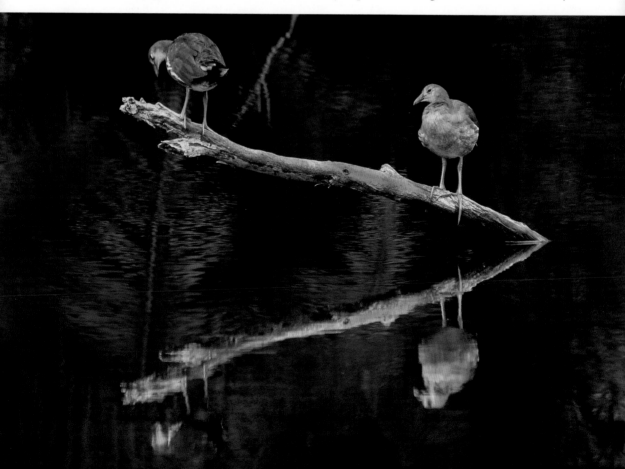

5. Insects and Spiders

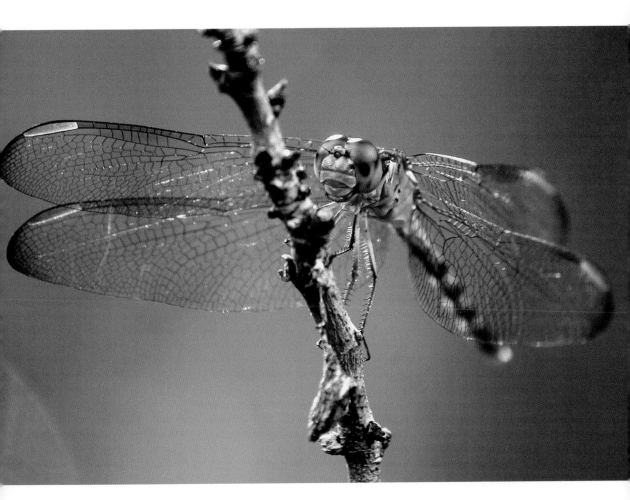

Dragonfly with Gold Wings

The golden wings and body of a dragonfly glow in the early morning sun at Bonnet House Museum & Gardens. This exposure was made, hand held, on October 11, 2015, using a Canon 55–250mm lens, set to a focal length of 250mm, on a Canon ESO 40D camera body. Using an ISO of 200, my exposure settings were $^1/_{50}$ second at f/5.6.

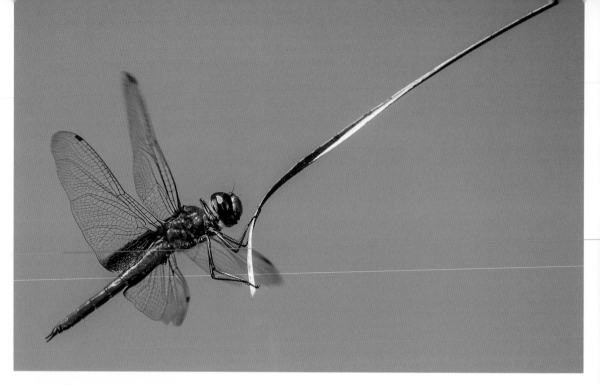

Red Diagonal Dragonfly (above)

A red dragonfly momentarily rests on the delicate tip of a narrow leaf high above the parking lot of Bonnet House Museum & Gardens. This image was made on October 13, 2015, with a Canon EOS 40D camera and a Canon 55–250mm lens set to a focal length of 250mm. Using an ISO of 200, my exposure was $^1/_{500}$ second at f/8.

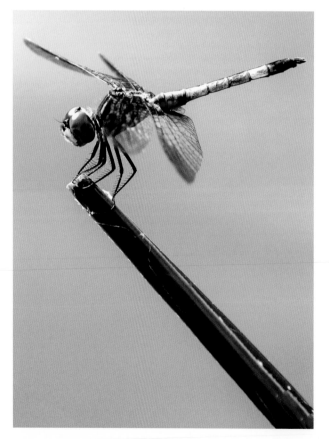

Blue Eye Dragonfly (left)

A dragonfly with spotted blue eyes perches delicately on a green reed in a lily pond at Bonnet House Museum & Gardens. This image was made with a Canon EOS 4D camera and a Canon 55–250mm lens set to a focal length of 250mm on Sept. 29 2015. Using an ISO of 400, my exposure was $^1/_{500}$ second at f/7.1.

Dragonfly, Formal Portrait (facing page)

This close-up view of a dragonfly posing for a formal portrait at Bonnet House Museum & Gardens was made May 10, 2016, with an Canon EOS 70 D camera with a Canon 55–250mm lens set to a focal length of 250mm. Using an ISO of 400, my exposure was $^1/_{400}$ second at f/7.1.

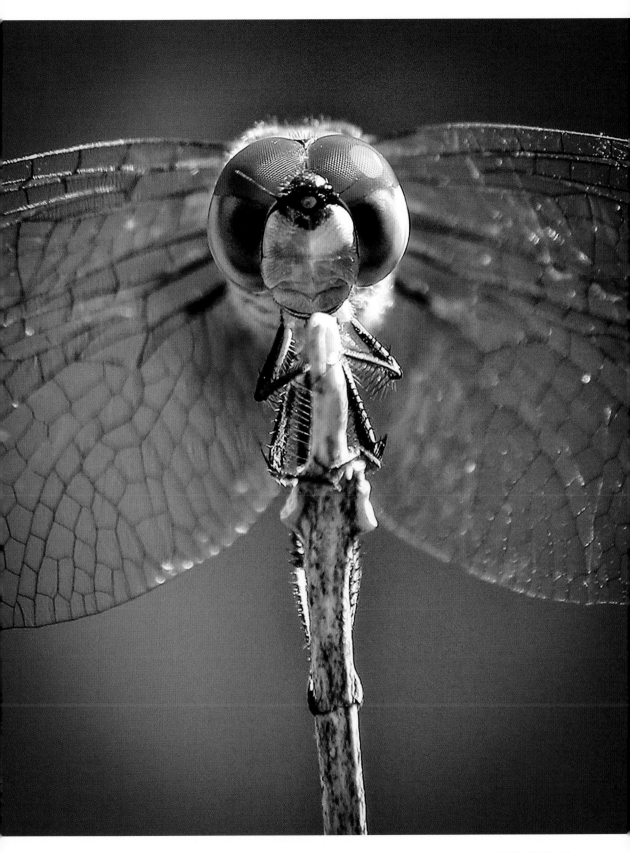

Blue Dragonfly *(facing page, top)*

This deep blue dragonfly, near the Welcome Center of Bonnet House Museum & Gardens, was photographed on June 12, 2016, with a Canon EOS 70D camera and a Canon a 55–250mm lens set at a focal length of 250mm. With an ISO of 500, my exposure was $^1/_{500}$ second at f/7.1.

Gold Dragonfly *(facing page, bottom)*

This image of a dragonfly with delicate and transparent wings was captured near the large lily pond at Bonnet House Museum & Gardens on June 18, 2016. I used a Canon EOS 70 camera with a Canon 55–250mm lens set to a focal length of 250mm. With an ISO of 1600, the exposure settings were $^1/_{2000}$ second at f/16.

Purple Eye Dragonfly *(below)*

A dragonfly, with glowing gold wings and a translucent body, sits on a strongly backlit green leaf near the lily pond of Bonnet House Museum & Gardens. This image was made on June 12, 2016, using a Canon EOS 70D camera and a Canon 55–250mm lens set to a focal length of 250mm. Using an ISO of 500, my exposure was $^1/_{400}$ second at f/7.1.

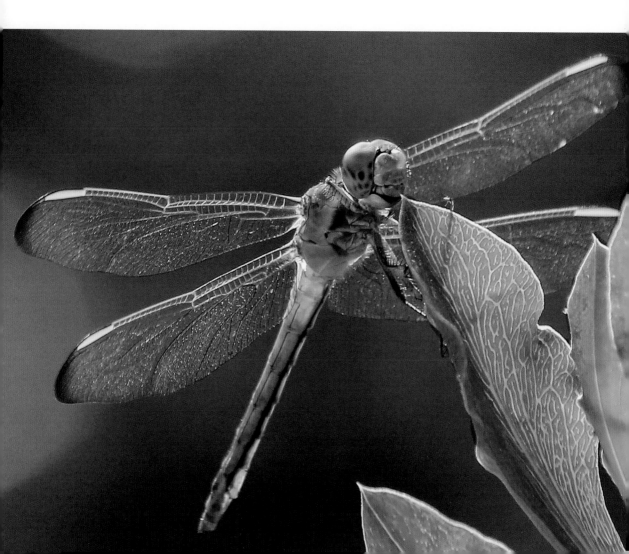

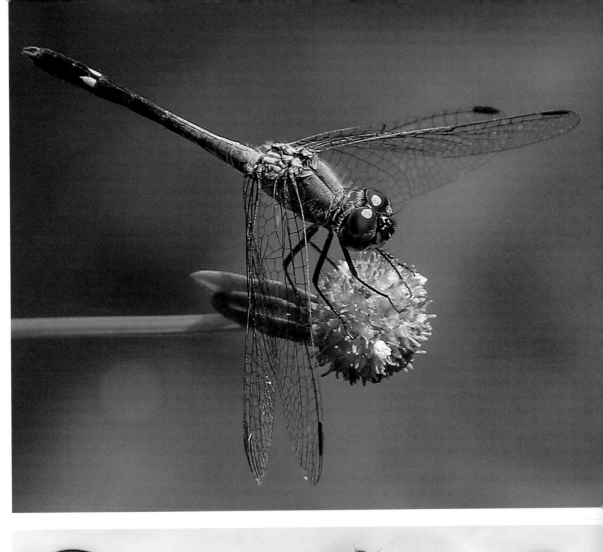

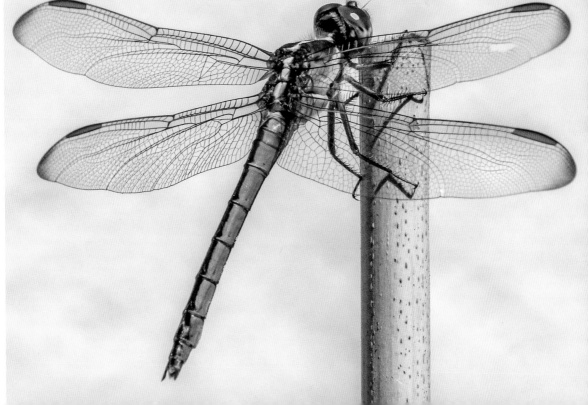

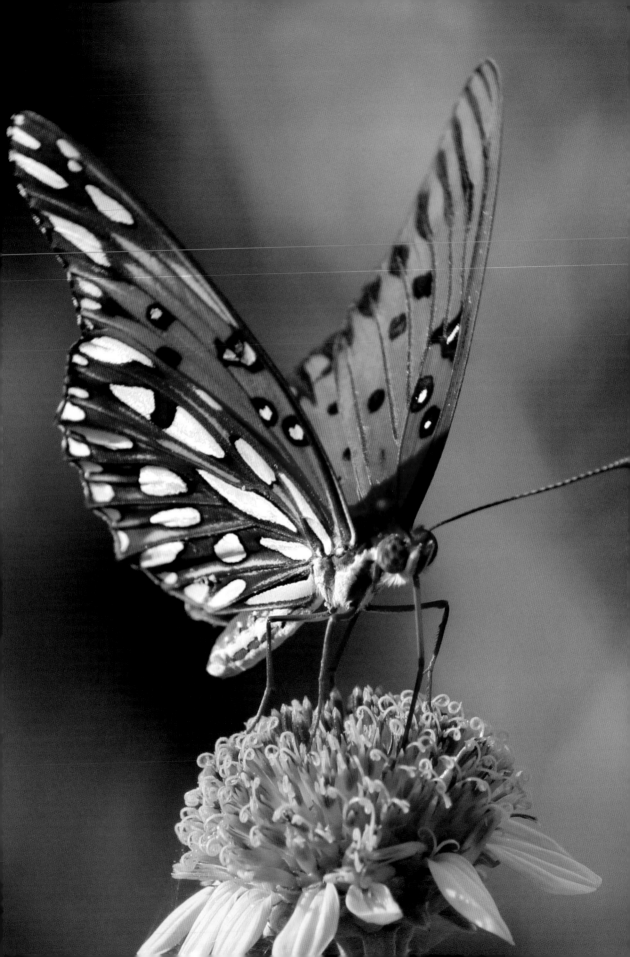

Gulf Frit (facing page)

This full-length portrait of a Gulf fritillary butterfly was made near the Welcome Center of Bonnet House Museum & Gardens on June 8, 2015. The Canon 55–250 lens on my Canon EOS 70D camera was set to a focal length of 250mm. Using an ISO rating of 400, my exposure was $1/640$ second at f/9.

White Peacock (right)

This backlit white peacock butterfly gathering nectar was photographed on July 19, 2015, near the Bonnet House Museum & Gardens Welcome Center. I used a Canon EOS 20D camera with a Canon 55–250mm lens set to a focal length of 250mm. With an ISO rating of 400, my exposure for this shot was $1/500$ second at f/8.

Gold Butterfly Stare (below)

A gold Ruddy Daggerwing butterfly stares directly at the camera on May 28, 2015, at Bonnet House Museum & Gardens. I used a Canon EOS 70D camera with a Canon 55–

250mm lens set to a focal length of 250mm. My exposure, using an ISO of 400, was $1/400$ second at f/7.1.

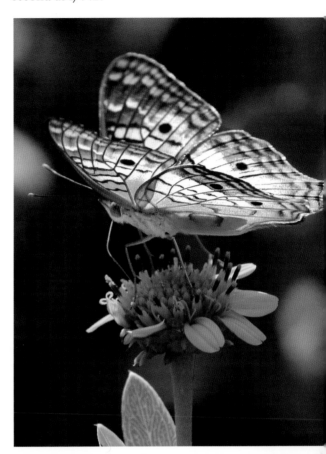

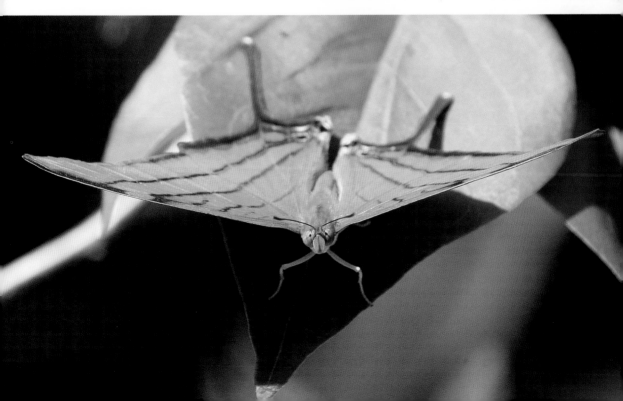

White Peacock, Formal Portrait (below)

A white peacock butterfly poses for a picture-perfect portrait on June 28, 2015, at Bonnet House Museum & Gardens. I used a Canon EOS 40 camera and a Canon 55–250mm lens set to a focal length of 250mm. Using an ISO rating of 400, my exposure was $1/800$ second at f/10.

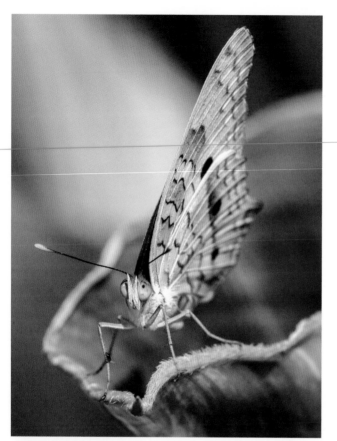

White Peacock, Close Up (bottom)

A gold Ruddy Daggerwing butterfly flashes a scary stare on June 12, 2015, at Bonnet House Museum & Gardens. I used a Canon EOS 70D camera with a Canon 55–250mm lens set to a focal length of 250mm. My exposure, using an ISO of 500, was $1/640$ second at f/9.

Diagonal Butterfly (facing page)

A white peacock butterfly spreads its wings to their maximum width on June 28, 2015, at Bonnet House Museum & Gardens. I used a Canon EOS 40 camera and a Canon 55–250mm lens set to a focal length of 250mm. Using an ISO rating of 100, my exposure was $1/400$ second at f/7.1.

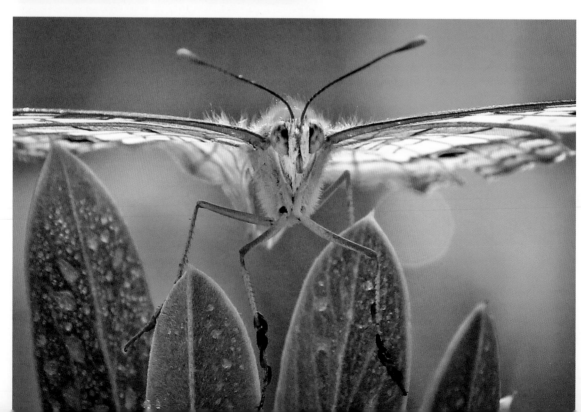

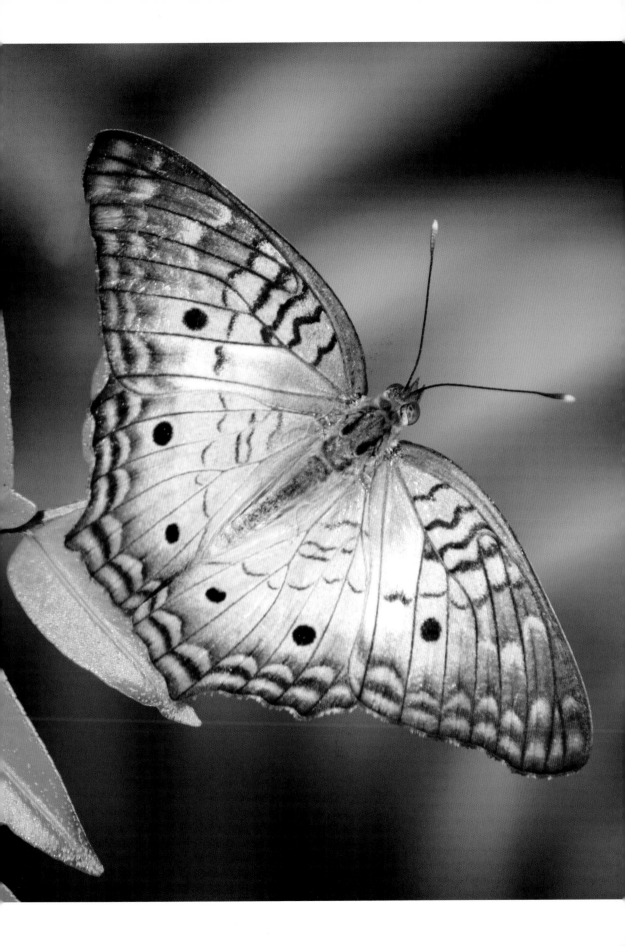

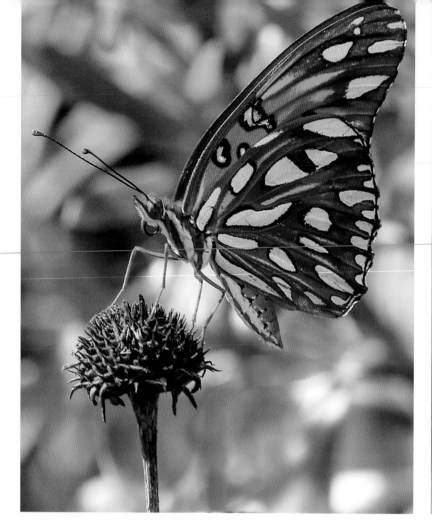

Gulf Frit Looking Left *(above)*

A Gulf fritillary butterfly poses for a full-length profile portrait near the Welcome Center of Bonnet House Museum & Gardens on June 12, 2016. The Canon 55–250mm lens on my Canon EOS 70D camera was set to a focal length of 250mm. Using an ISO rating of 500, my exposure was $^{1}/_{500}$ second at f/8.

Gulf Fritillary Portrait *(facing page, top)*

A Gulf fritillary butterfly poses for a head-on formal portrait shot near the Welcome Center of Bonnet House Museum & Gardens on June 12, 2015. The Canon 55–250mm lens on my Canon EOS 70D camera was set to a focal length of 250mm. Using an ISO rating of 500, my exposure was $^{1}/_{500}$ second at f/7.1.

Gold Butterfly *(facing page, bottom)*

A Gulf fritillary butterfly spreading its wings was shot from above near the Welcome Center of Bonnet House Museum & Gardens on May 19, 2015. The Canon 55–250mm lens on my Canon EOS 70D camera was set to a focal length of 220mm. Using an ISO rating of 800, my exposure was $^{1}/_{640}$ second at f/8.

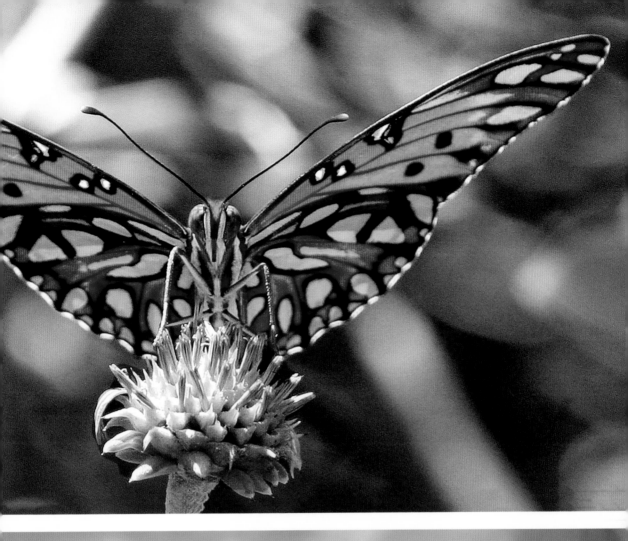

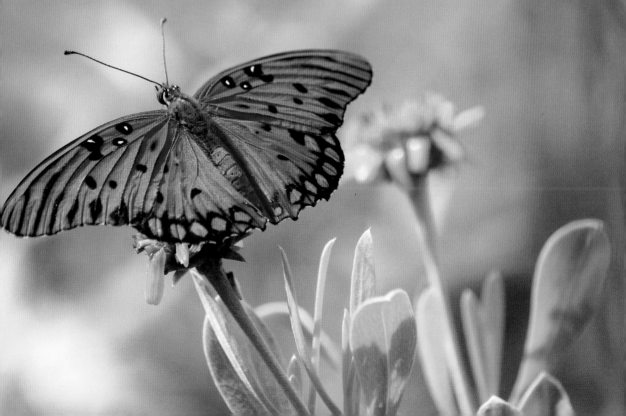

Crab Spider (below)

A tiny, often difficult to see, red and white crab spider, waits for breakfast to arrive in the center of its web near the lily pond at Bonnet House Museum & Gardens on March 25, 2015. To capture this image, I used a Canon EOS 40D camera with a Sigma 50–500mm lens set to a focal length of 266mm. Using an ISO rating of 1600, my exposure was $1/500$ second at f/8.

Top View of Crab Spider

(bottom, left)

A tiny, front-lit crab spider with white hair on its legs waits for breakfast to arrive at Bonnet House Museum & Gardens on November 1, 2015. To capture this image, I used a Canon EOS 70D camera with a Canon 55–250mm lens set to a focal length of 250mm. Using an ISO rating of 1600, my exposure was $1/1250$ second at f/11.

Crab Spider Web (facing page)

The angled rays of early morning sunlight hitting the web of a tiny crab spider, turns its nearly invisible silk trap into a colorful display at Bonnet House Museum & Gardens on October 10, 2015. To capture this image, I used a Canon EOS 40D camera with a Canon 55–250mm lens set to a focal length of 250mm. Using an ISO rating of 200, my exposure was $1/160$ second at f/5.6.

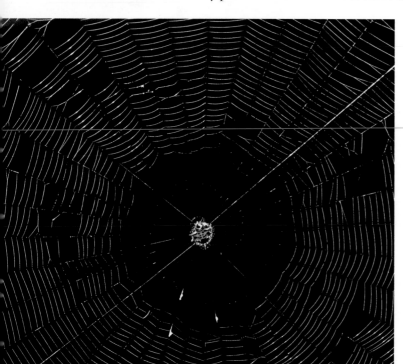

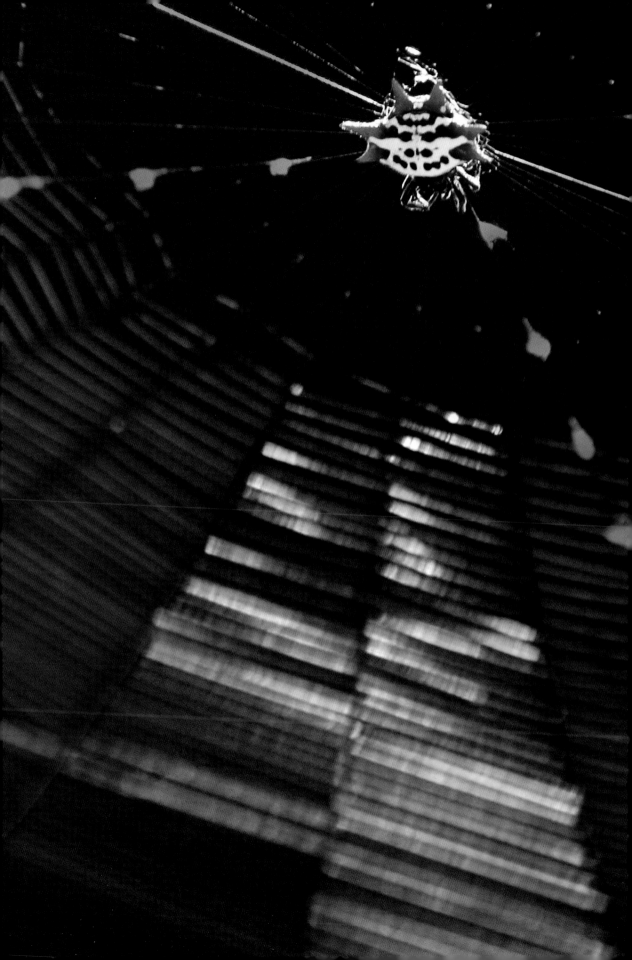

Top View of Banana Spider (below)

A large banana spider waited for breakfast in its web. From this angle, the spider's head resembles a human skull—and two light-brown pincers can be seen. To capture this image I used a Canon EOS 70D camera with a Canon 55–250mm lens set to a focal length of 250mm. Using an ISO rating of 1600, my exposure was $\frac{1}{500}$ second at f/8.

Banana Spiders (facing page)

Two backlit gold, black, and tan banana spiders wait for prey while suspended high above a walking path at Bonnet House Museum & Gardens on June 28, 2015. To capture this, I used a Canon EOS 20D camera with a Canon 55–250mm lens set to a focal length of 250mm. Using an ISO light sensitivity rating of 400, my exposure was $\frac{1}{800}$ second at f/9.

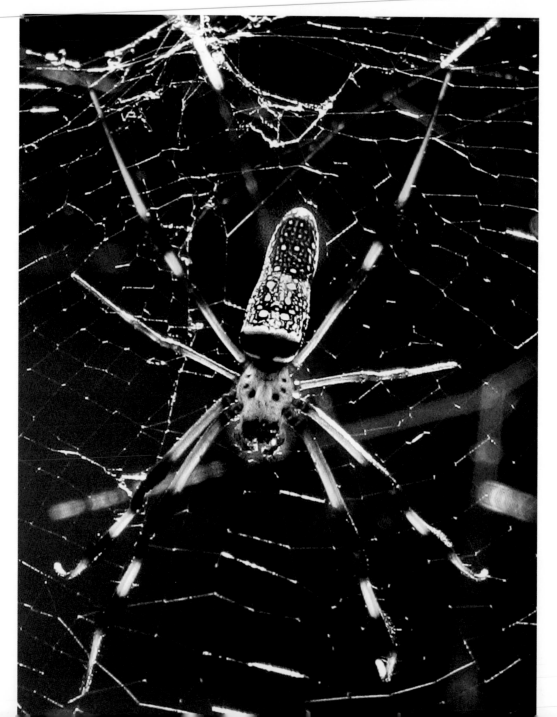

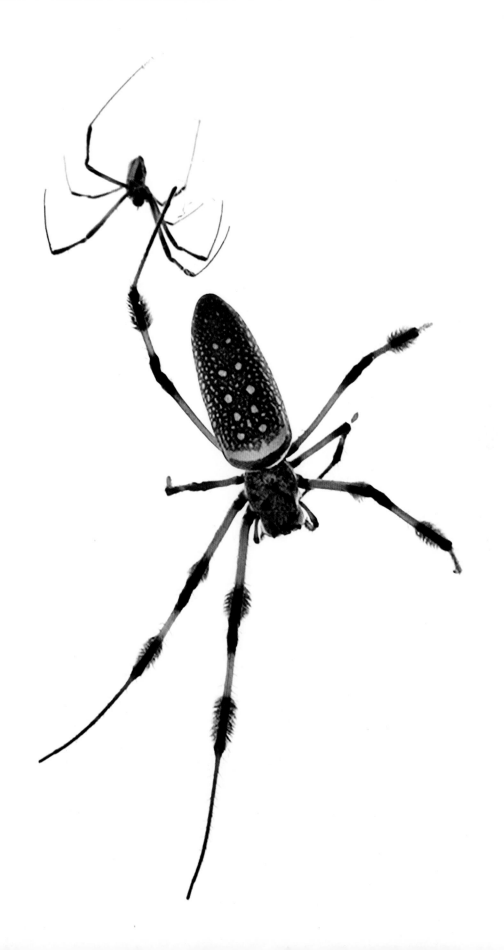

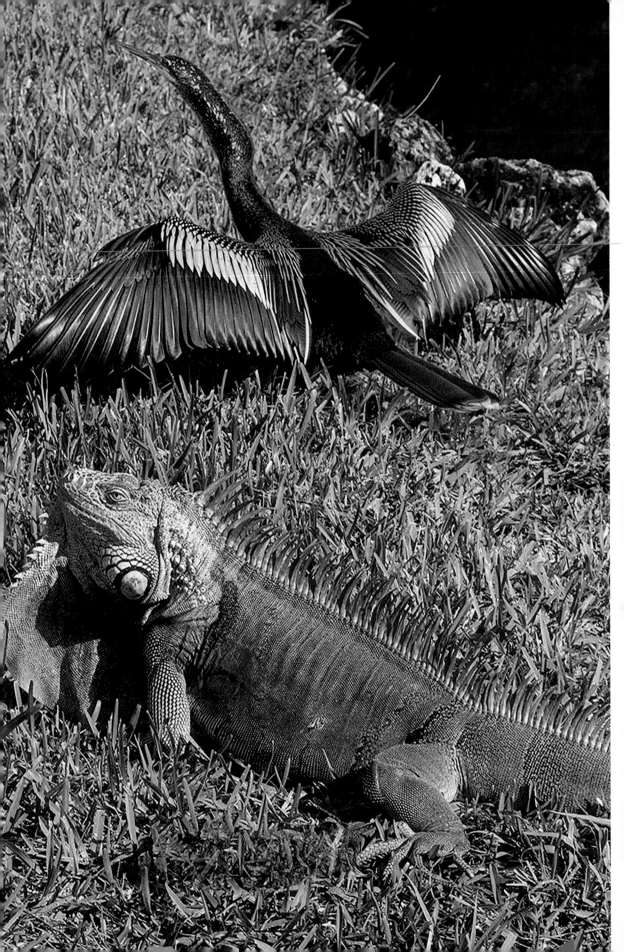

6. Reptiles and Amphibians

Bonnet House Sunbathers (facing page)
A large, gold iguana warms itself in the morning sun next to an anhinga drying its wings after a seafood breakfast on February 16, 2016. I used a Canon EOS 70D camera and a Canon 55–250mm lens set to a focal length of 250mm. With an ISO rating of 1600, my exposure was $1/1200$ second at f/11.

Sassy Green Iguana (below)
A large green iguana, one of a hundred estimated to be living on the estate, sticks out his tongue at Bonnet House Museum & Gardens on July 2, 2015. I used a Canon EOS 40D camera and a Canon 55–250mm lens set to a focal length of 250mm. With an ISO rating of 400, my exposure was $1/640$ second at f/9.

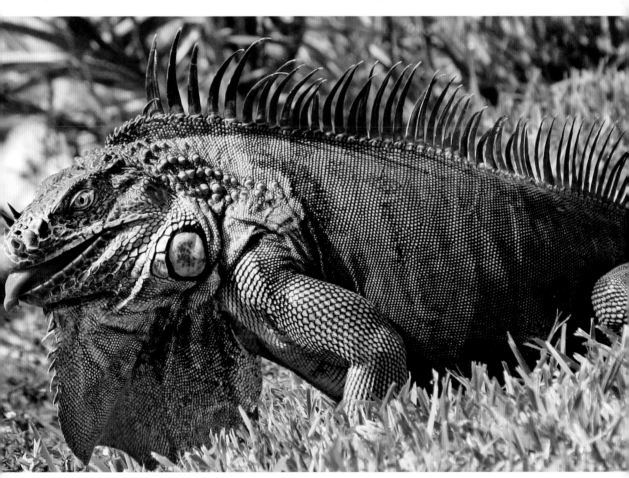

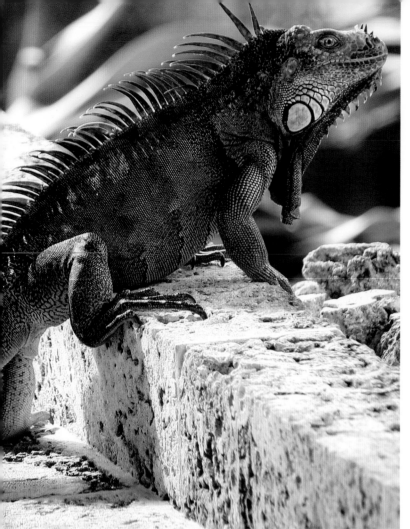

Iguana Portrait *(facing page)*

A large, antisocial iguana briefly poses for a portrait at Bonnet House Museum & Gardens on June 25, 2015. I used a Canon EOS 20D camera and a Canon 55–250mm lens set to a focal length of 250mm. With an ISO rating of 400, my exposure was $^1/_{500}$ second at f/7.1.

Wild Green Iguana *(top left)*

A wild green iguana climbs a low coquina wall at Bonnet House Museum & Gardens in Fort Lauderdale, Florida, on July 11, 2015. I used a Canon EOS 40D camera and a Canon 55–250mm lens set to a focal length of 171mm. With an ISO rating of 400, my exposure was $^1/_{160}$ second at f/5.6.

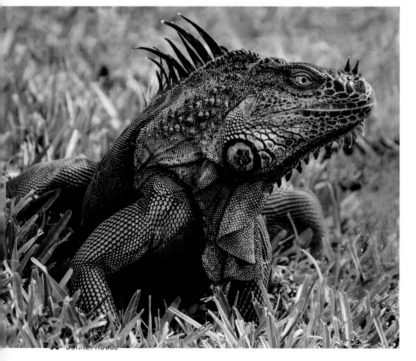

Full Iguana Portrait *(bottom left)*

A large, wild iguana poses for a full-length portrait at Bonnet House Museum & Gardens on July 28, 2015. I used a Canon EOS 40D camera and a Canon 55–250mm lens set to a focal length of 208mm. With an ISO rating of 400, my exposure was $^1/_{400}$ second at f/7.1.

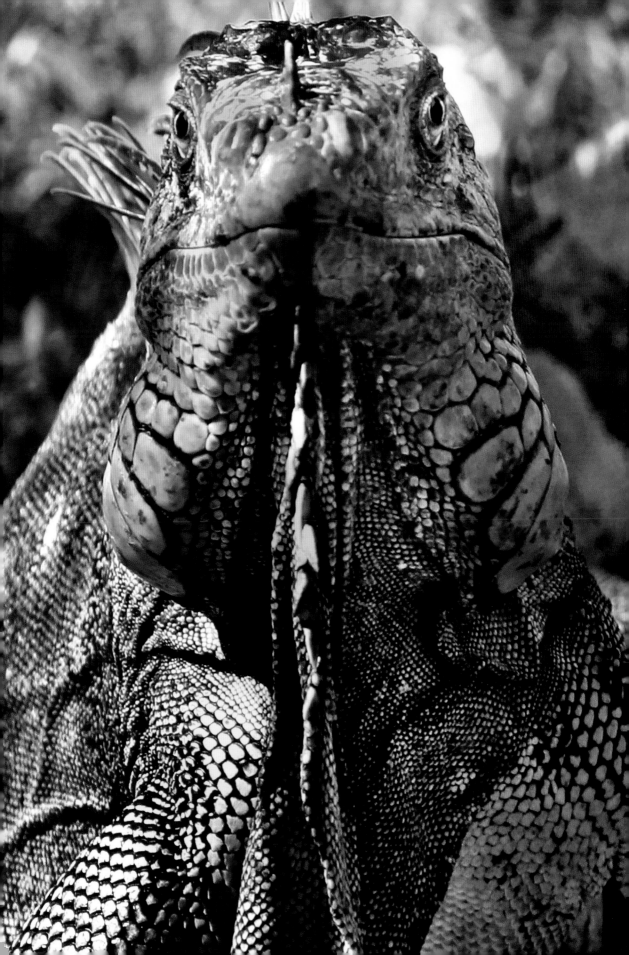

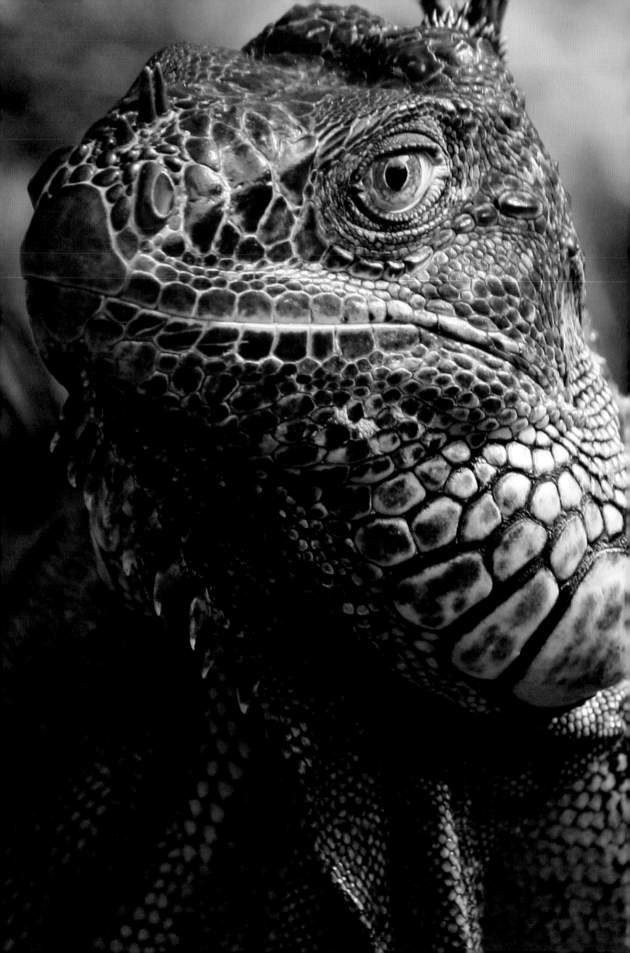

Iguana Portrait *(left)*

A green iguana briefly poses for a portrait at Bonnet House Museum & Gardens on July 28, 2015. I used a Canon EOS 40D camera and a Canon 55–250mm lens set to a focal length of 250mm. With an ISO rating of 400, my exposure was $1/250$ second at f/6.3.

Two Green Iguanas *(below)*

Two small green iguanas warm up in the morning sun at Bonnet House Museum & Gardens on June 15, 2016. I used a Canon EOS 70D camera and a Canon 55–250mm lens set to a focal length of 250mm. With an ISO rating of 400, my exposure was $1/640$ second at f/9.

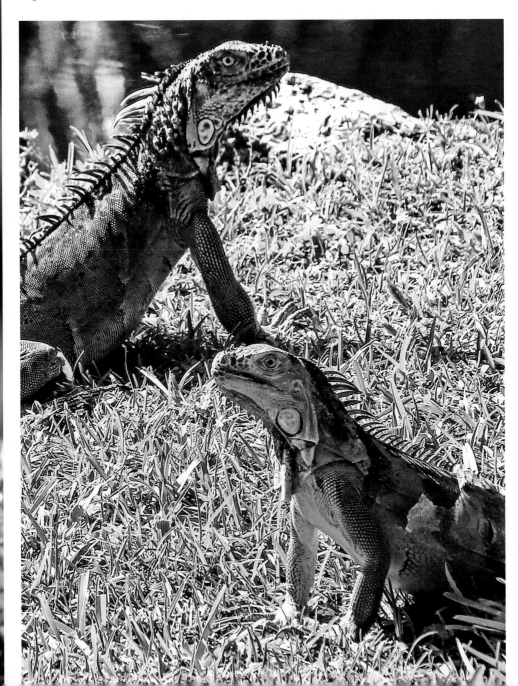

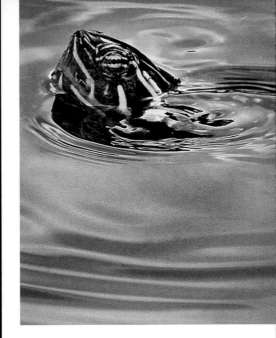

Mossy Turtles (left)

Two Florida red-bellied turtles, their shells covered with moss, come up for air while paddling near the shore of a lily pond adjacent to Bonnet House Museum & Gardens. This picture was shot on May 5, 2015, with a Canon EOS 20D camera and a 55–250mm lens set to a focal length of 154mm. With an ISO of 400, my exposure was $1/250$ second at f/6.3.

Red-Bellied Turtle (above)

I waited longer than I would have liked to get one nice shot of this red-bellied turtle. I was amazed at how the lines in the turtle's eye perfectly fit into its entire facial pattern. I used a Canon EOS 20 camera with a Canon 55–250mm lens set to a focal length of 250mm. With an ISO of 400, my exposure was $1/500$ second at f/7.1.

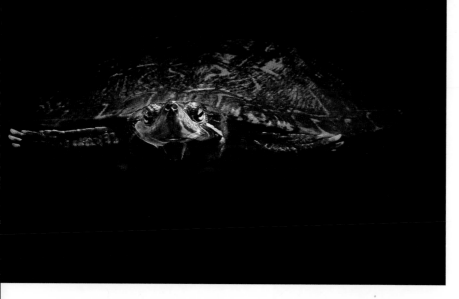

Florida Red-Bellied Turtle Portrait *(above)*

A Florida red-bellied turtle takes in a breath of fresh air while looking for breakfast near the shore of a lily pond adjacent to Bonnet House. This turtle portrait was shot on May 5, 2015, with a Canon EOS 20 D camera and a 55–250mm lens set to a focal length of 250 mm. With an ISO of 400, my exposure was $1/250$ second at f/5.6.

Turtle Profile *(below)*

One morning, angled rays of sunlight illuminated a small bale of turtles swimming just below the surface of the large Bonnet House lily pond. After waiting several minutes for them to surface near me, I was ready when one of them poked his head out of the water a few feet away and looked directly into the lens of my camera. This picture was taken on May 25, 2015, with a Canon EOS 20D camera and a 55–250mm lens set to a focal length of 250mm. With the ISO set at 400, my exposure was $1/320$ second at f/5.6.

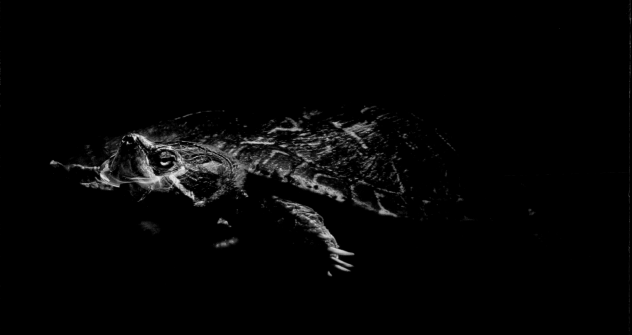

7. Monkey Business

Spider Monkey

One of three Costa Rican spider monkeys shows off a bit of personality while posing for a very casual portrait on December 26, 2015, at Bonnet House Museum & Gardens. It is one of the three remaining monkeys that were once part of a larger group. This picture was taken with a Canon EOS 70D camera with a Canon 55–250mm lens set to a focal length of 220mm. With an ISO rating of 800, my exposure was $1/320$ second at f/5.6.

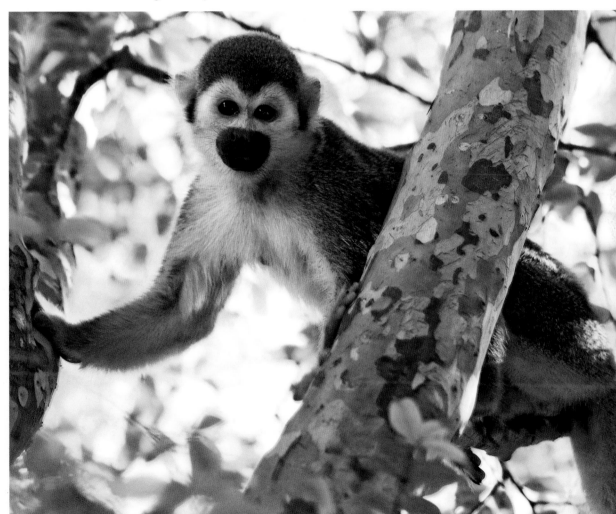

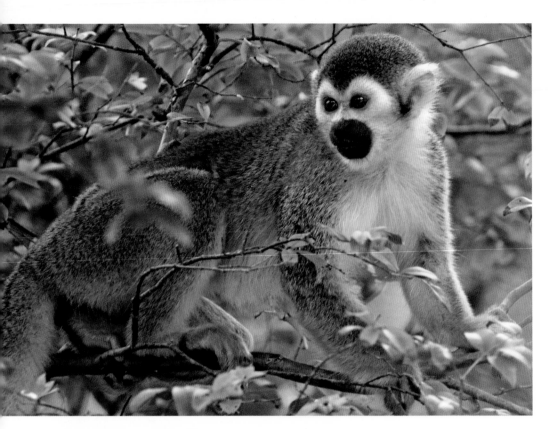

Costa Rican Spider Monkey, Informal Portrait (above)

One of three Costa Rican spider monkeys poses for an informal portrait on December 26, 2015, at Bonnet House Museum & Gardens. This monkey is one of just three that now remain from a large group that once had the run of the entire 35-acre Bonnet House estate. This picture was taken with a Canon EOS 70D camera with a Sigma 50–500mm lens set to a focal length of 500mm. With an ISO rating of 1600, my exposure was $1/400$ second at f/7.1.

Costa Rican Spider Monkey (facing page)

A Costa Rican spider monkeys at Bonnet House Museum & Gardens poses for a portrait on October 31, 2015. This picture was taken with a Canon EOS 70D camera with a Canon 55–250mm lens set to a focal length of 250mm. With an ISO rating of 1600, my exposure was $1/1600$ second at f/7.1.

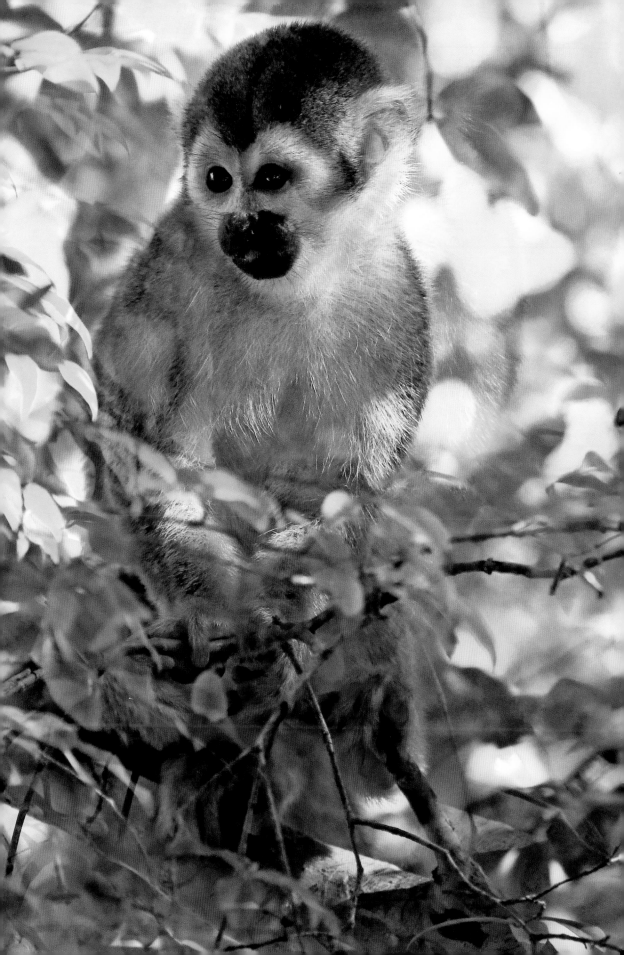

Costa Rican Spider Monkey Portrait (below)

A Costa Rican spider monkey poses for a head-and-shoulders portrait on December 26, 2015. This picture was taken with a Canon EOS 70D camera with a Sigma 50–500mm lens set to a focal length of 191mm. With an ISO rating of 1600, my exposure was $^1/_{640}$ second at f/8.

Costa Rican Spider Monkey, Head and Shoulders (facing page)

This picture was taken with a Canon EOS 70D camera with a Sigma 50–500mm lens set to a focal length of 363mm. With an ISO rating of 1600, my exposure was $^1/_{1000}$ second at f/11.

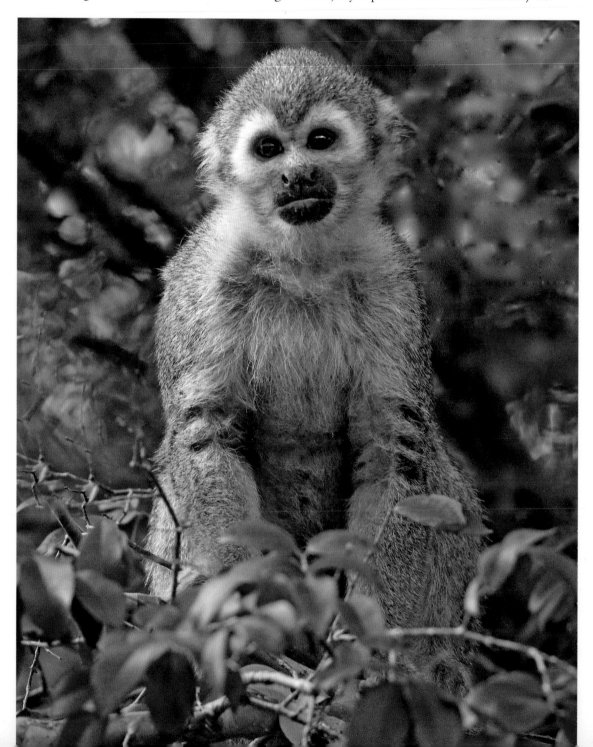

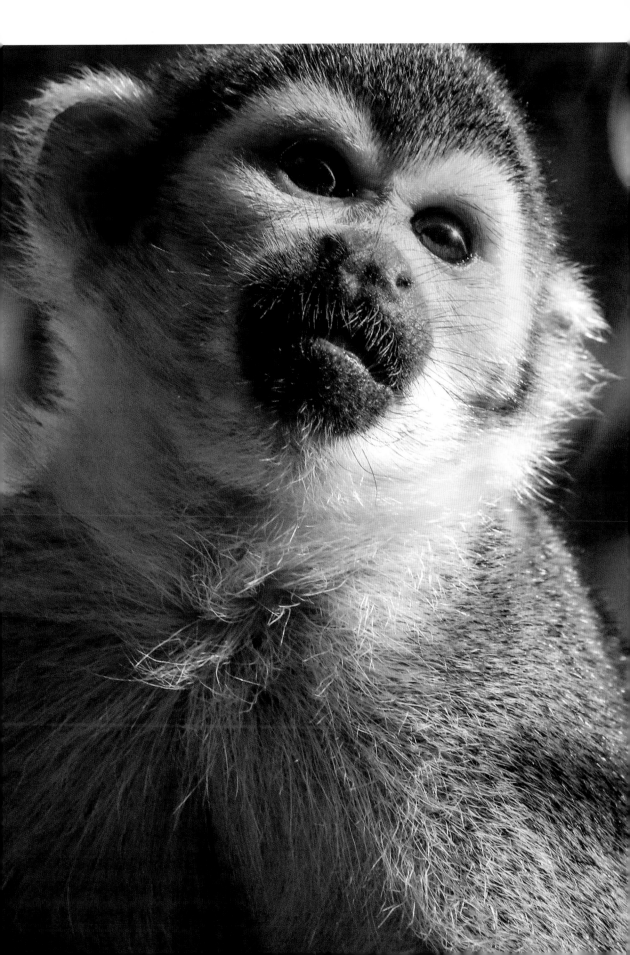

8. Miscellaneous Plants

Palm Tree Covered by Cereus Cacti *(bottom left)*

The trunk of a palm tree at Bonnet House Museum & Gardens is completely covered by a matted tangle of prickly, snakelike cereus cacti. This image was made on January 11, 2016, with a Canon EOS 70D camera with a Canon 10–18mm lens set to a focal length of 10mm. Using an ISO rating of 1600, my exposure was $1/200$ second at f/10.

Cereus Cactus Bloom Dying *(bottom right)*

A group of orange, night-blooming cereus cactus blooms, resembling flamingos, are photographed shortly after sunrise at Bonnet House Museum & Gardens on October 21, 2015. This image was made with a Canon EOS 7D camera with a 55–250mm Canon lens set to a focal length of 225mm. Using an ISO rating of 400, my exposure was $1/100$ second at f/11.

Folded Cereus Cactus Bloom *(facing page)*

A folded cereus cactus bloom (resembling a multi-colored, soft-serve ice cream cone) is shown shorty after blossoming at Bonnet House Museum & Gardens on August 6, 2015. This image was made with a Canon EOS 70D camera with a 55–250mm Canon lens set to a focal length of 146mm. Using an ISO rating of 400, my exposure was $1/400$ second at f/7.1.

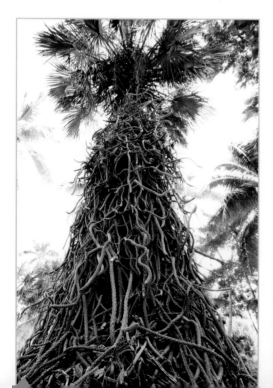

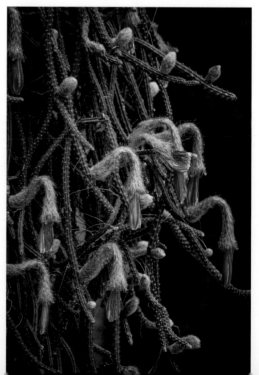

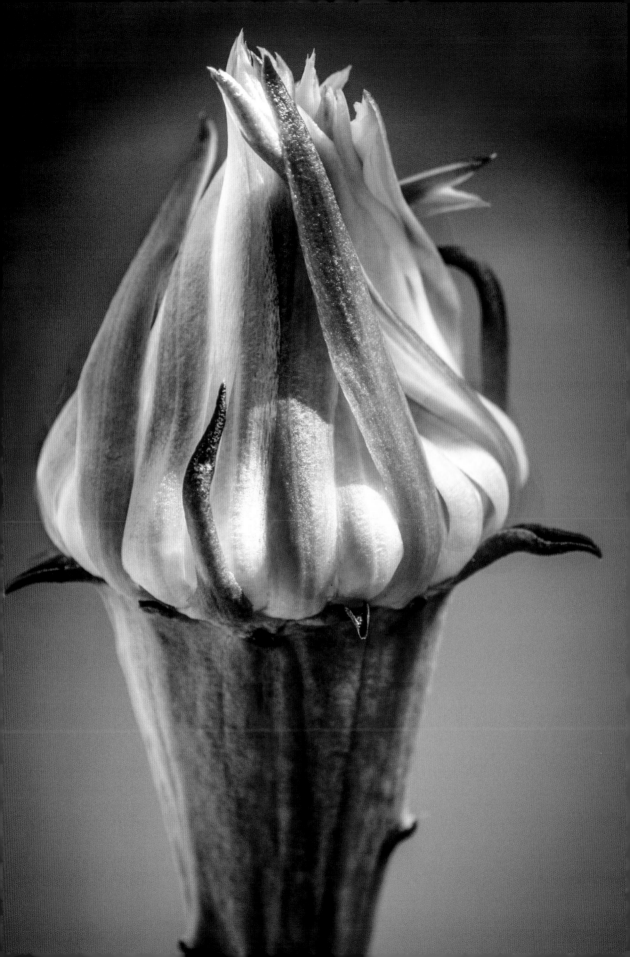

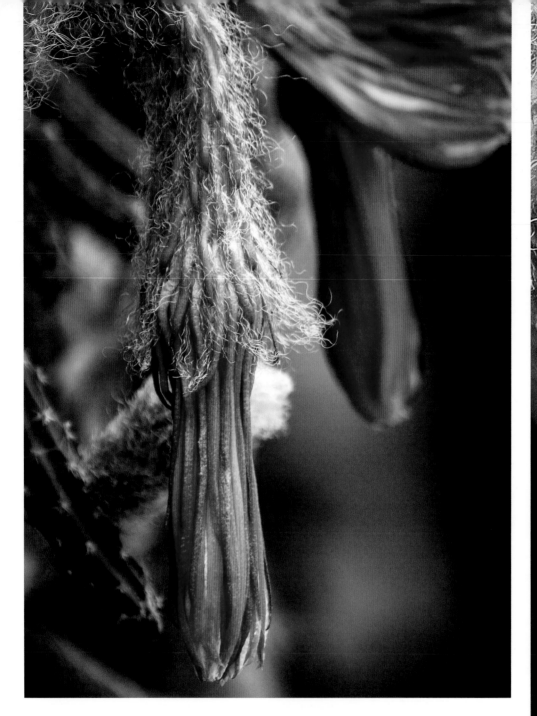

Cereus Cactus Bloom Dying *(above and facing page)*

Orange, rapidly wilting blossoms from the night-blooming cereus cactus plant begin to shrivel shortly after sunrise at Bonnet House Museum & Gardens on July 7, 2015. This image was made with a Canon EOS 40D camera with a 55–250mm Canon lens set to a focal length of 200mm. Using an ISO rating of 400, my exposures were made at $^1/_{200}$ second and f/11 (above) and $^1/_{200}$ second at f/6.3 (facing page).

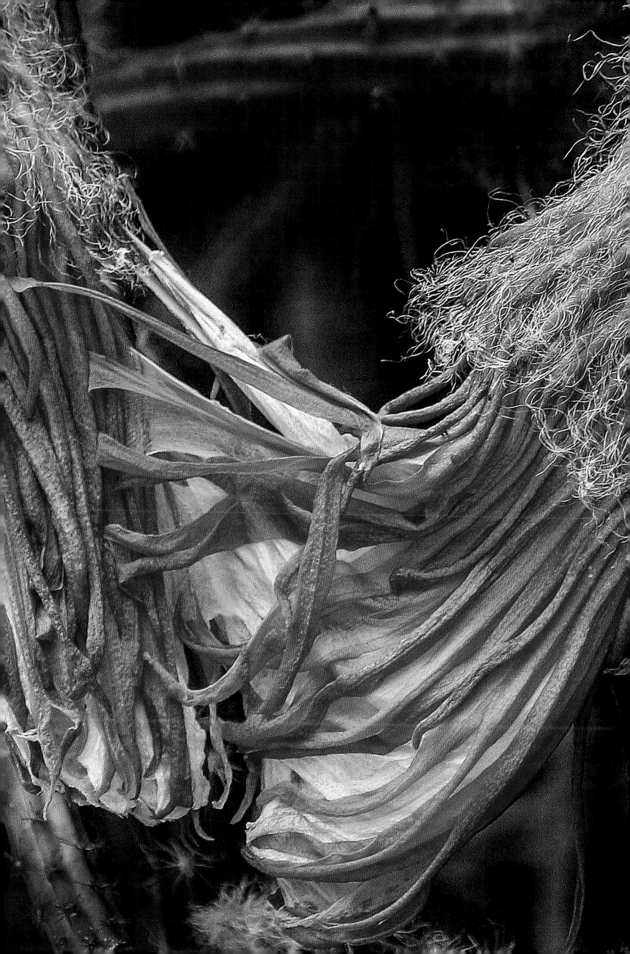

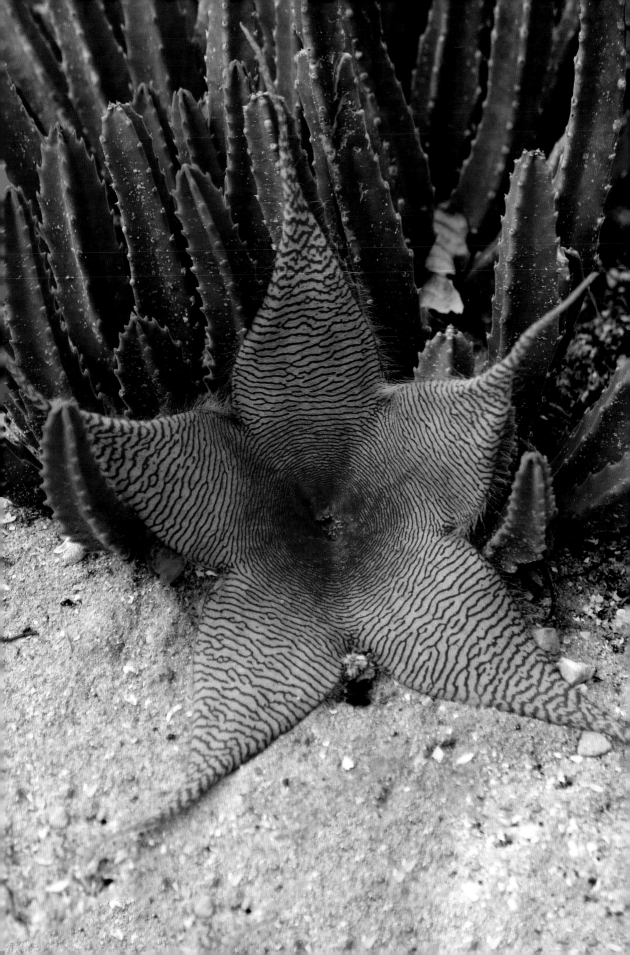

Starfish Flower Cactus (facing page)

A blossoming starfish flower, notorious for emitting an unpleasant carrion stench that attracts green bottle flies, was photographed at Bonnet House Museum & Gardens on June 15, 2016. I used a Canon EOS 70D camera with a 55–250mm Canon lens set to a focal length of 146mm. Using an ISO rating of 400, my exposure was $1/250$ second at f/5.

Backlit Cereus Cactus (below)

This backlit, early-morning image of a cereus cactus was taken on October 21, 2015, at Bonnet House Museum & Gardens with a Canon EOS 7 camera and a 55–250mm Canon lens set to a focal length of 225mm. Using an ISO rating of 400, my exposure was $1/1000$ second at f/11.

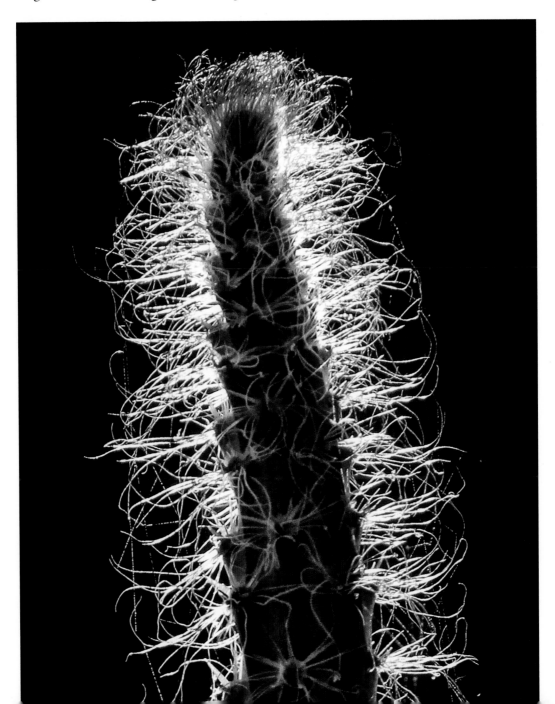

Backlit Cactus Leaves (below)

The sharply pointed edges of an agave cactus are brightly backlit and outlined by the early morning sun at Bonnet House Museum & Gardens on June 18, 2016. This image was made with a Canon EOS 70D camera with a 55–250mm Canon lens set to a focal length of 146mm. Using an ISO rating of 1600, my exposure was $^1/_{1000}$ second at f/11.

Backlit Yellow Sea Grape Leaves (facing page)

Two yellow sea grape leaves, photographed next to the parking lot of Bonnet House Museum & Gardens, glowed with an ethereal luminosity on May 21, 2015. I used a Canon EOS 70D camera with a 55–250mm Canon lens set to a focal length of 146mm. Using an ISO rating of 100, my exposure was $^1/_{250}$ second at f/5.6

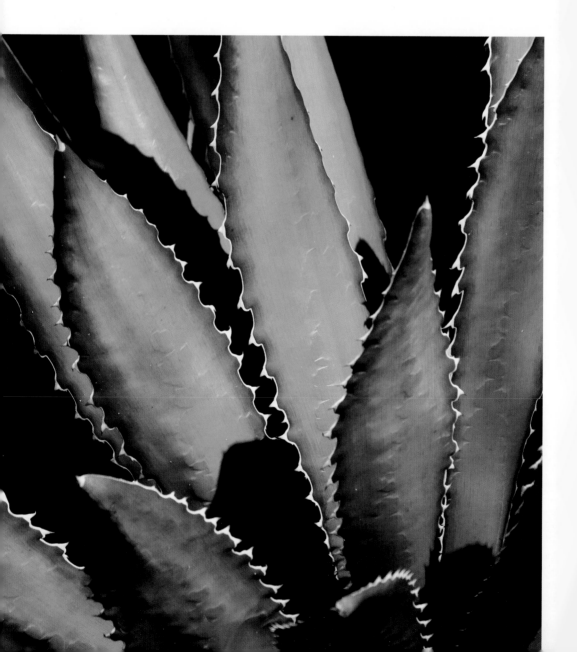

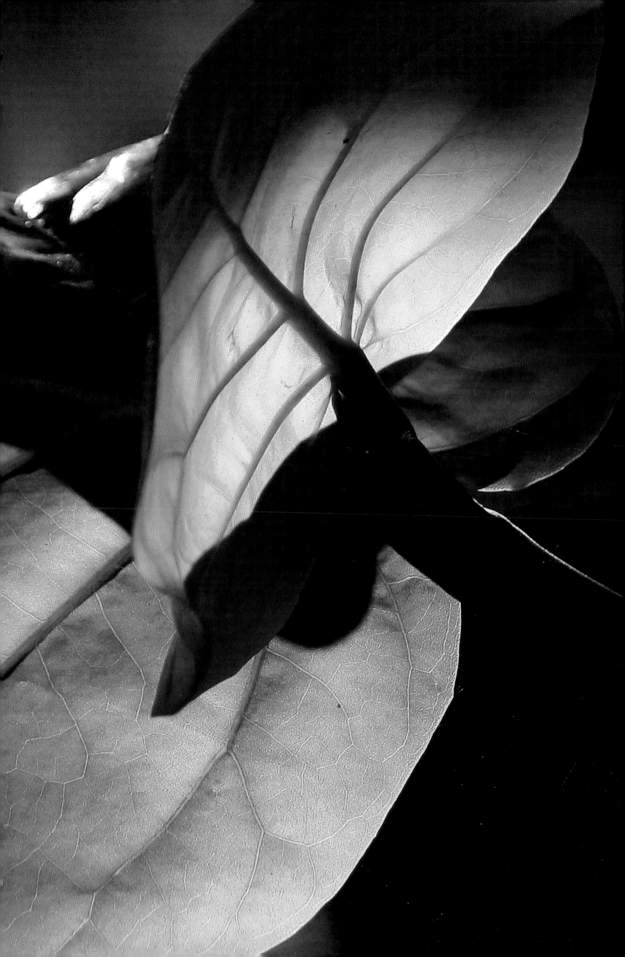

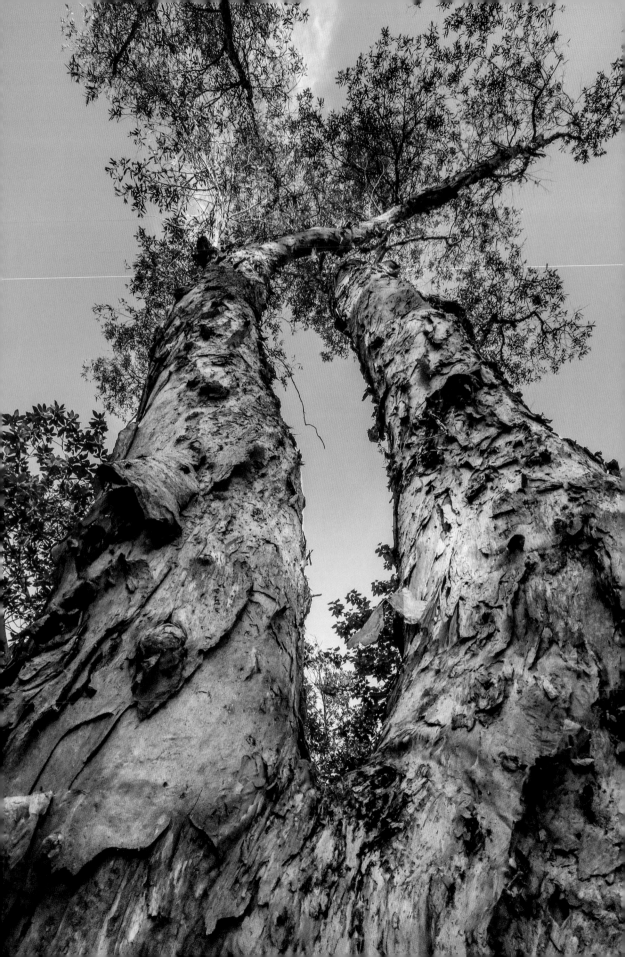

River Birch Tree (left)

A river birch tree, with chunks of peeling and deeply pitted bark, forms two towering branches at Bonnet House Museum & Gardens on December 29, 2015. To capture this image, I used a Canon EOS 70D camera with a Canon 10-18mm Canon lens set to a focal length of 10mm. Using an ISO rating of 1600, my exposure was $1/320$ second at f/14.

A Flood of Beauty (below)

The underside of a glowing yellow sea grape leaf is reflected on the surface of a shallow stream, recently created during several days of heavy rain and minor flooding on some of the Bonnet House Museum & Gardens grounds. To capture this image, which was taken on October 1, 2015, I used a Canon EOS 40D camera with a Canon 55–250mm lens set to a focal length of 250mm. Using an ISO rating of 200, my exposure was $1/85$ second at f/5.6.

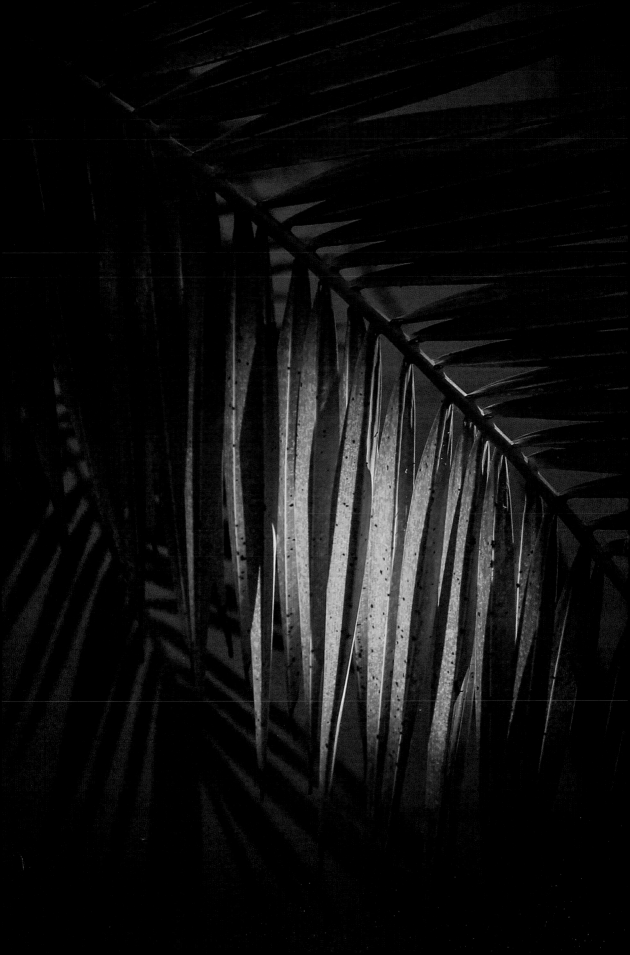

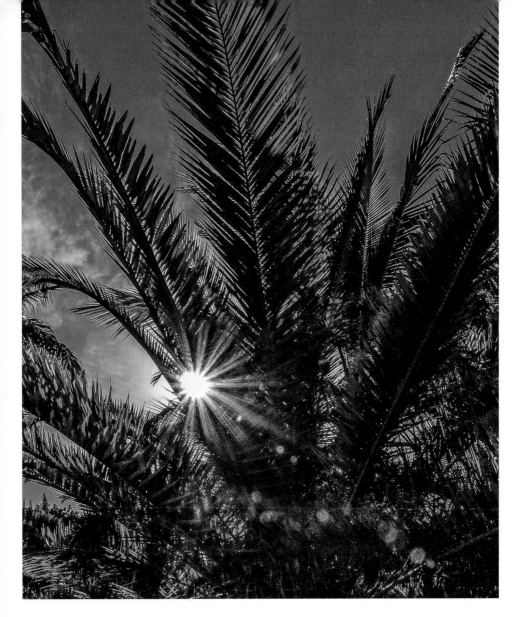

Partially Backlit Palm Tree (left)

The center section leaves of a deeply shadowed palm frond are illuminated while back-lit by a narrow beam of sunlight at Bonnet House Museum & Gardens. To capture this image, which was created on July 9, 2016, I used a Canon EOS 70D camera with a Canon 55–250mm lens set to a focal length of 85mm. Using an ISO rating of 400, my exposure was $1/400$ second at f/8.

Palm Sunburst (above)

A gold burst of early morning sunlight pierces the leaves of a palm frond at Bonnet House Museum & Gardens. To capture this image, which was created on June 29, 2016, I used a Canon EOS 70D camera with a Canon 10–18mm lens set to a focal length of 16mm. Using an ISO rating of 400, my exposure was $1/250$ second at f/5.

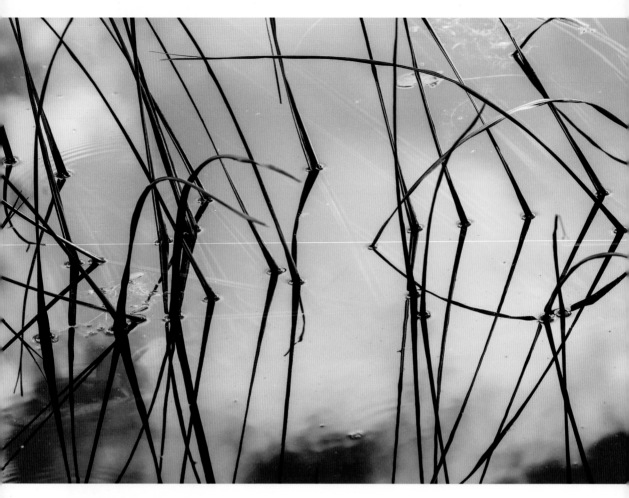

Reed Abstract Reflections (above)

Partially submerged water plants cast a graphic reflection in a lily pond at Bonnet House Museum & Gardens on June 15, 2016. To capture this image, I used a Canon EOS 70D camera with a Canon 55–250mm lens set to a focal length of 90mm. Using an ISO rating of 400, my exposure was $1/400$ second at f/7.1.

Palm Frond Rainbow (facing page)

Palm fronds, backlit by the morning sun on June 29, 2016, refract a rainbow of nature's colors. I used a Canon EOS 70D camera with a Canon 10–18mm lens set to a focal length of 10mm. Using an ISO rating of 1600, my exposure was $1/320$ second at f/4.

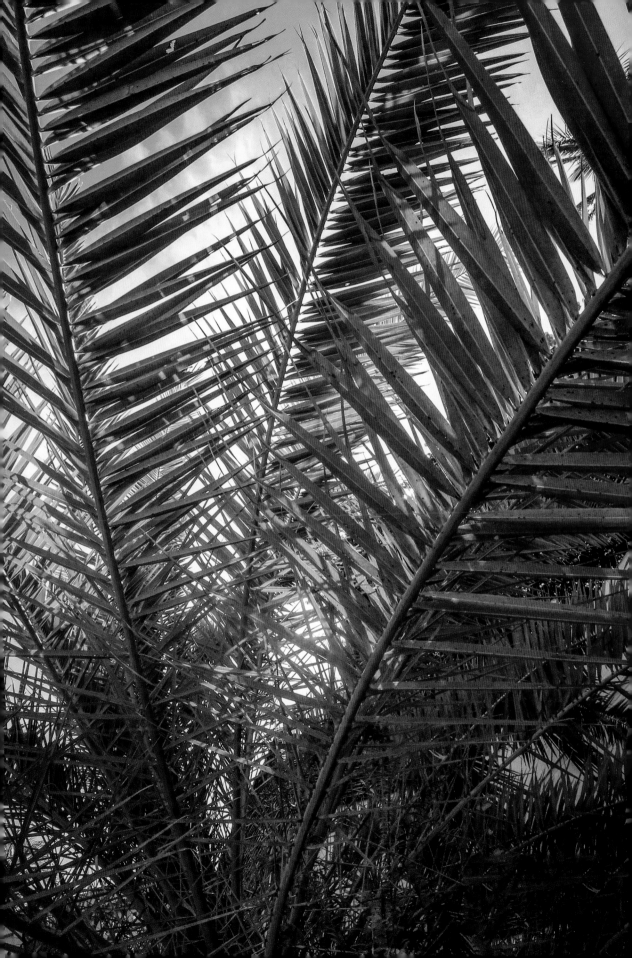

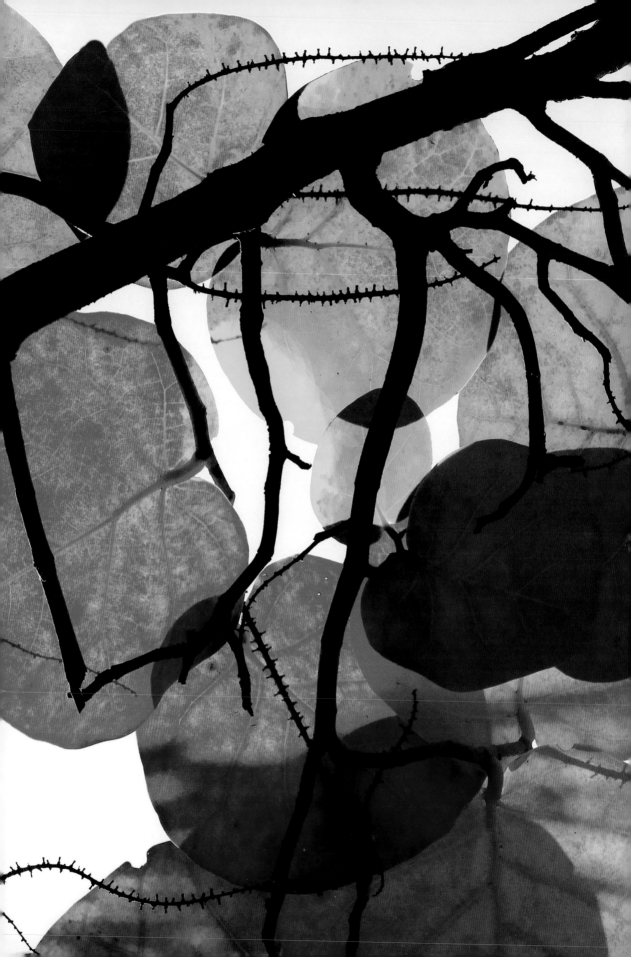

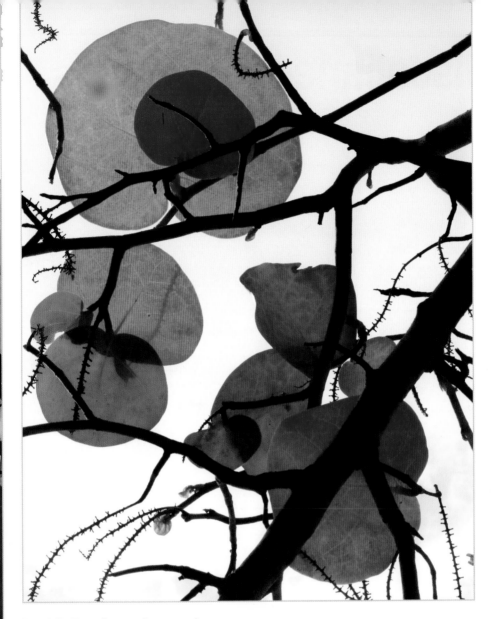

Backlit Sea Grape Leaves 1 (facing page)

Sea grape leaves, backlit and glowing in the early morning sunlight on June 29, 2016, create a dramatic abstract rainbow of earth-tone colors at Bonnet House Museum & Gardens. To capture this image, I used a Canon EOS 70D camera with a Canon 55–250mm lens set to a focal length of 84mm. Using an ISO rating of 1600, my exposure was $^1/_{1000}$ second at f/14.

Backlit Sea Grape Leaves 2 (above)

Multicolored leaves from a sea grape tree at Bonnet House Museum & Gardens glow brightly when backlit by the sun's rays on March 18, 2016. To capture this image, I used a Canon EOS 70D camera with a Canon 55–250mm lens set to a focal length of 79mm. Using an ISO rating of 6400, my exposure setting was $^1/_{2700}$ second at f/14.

9. Miscellaneous Animals

Eye Full of Flowers (below)

This image of flowers reflected in the eyes of a bee was taken on my first visit to Bonnet House Museum & Gardens on February 27, 2015. This picture was used on the cover of *Bee Culture* magazine (below). I used a Canon EOS 20D camera and a Sigma 17–70mm lens set to a focal length of 70mm. Using an ISO rating of 1600, my exposure was ¹⁄₄₀₀ second at f/11.

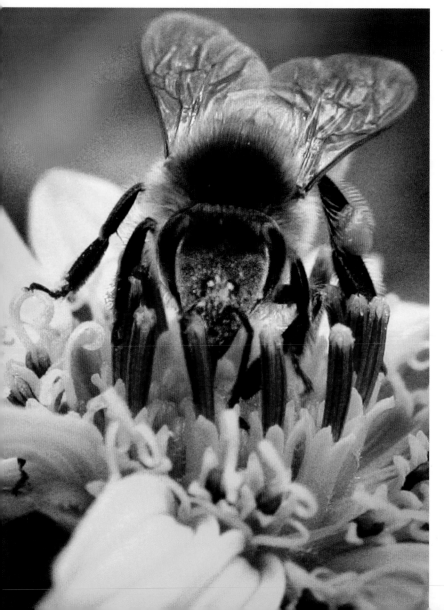

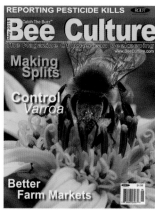

Transparent Wings

(facing page)

The brown and black striped body of a honeybee can be seen through its transparent wings as it gathers pollen at Bonnet House Museum & Gardens. I used a Canon EOS 20D camera and a Canon 55–250mm lens set to a focal length of 250mm. With an ISO rating of 400, my exposure was ¹⁄₃₂₀ second at f/5.6.

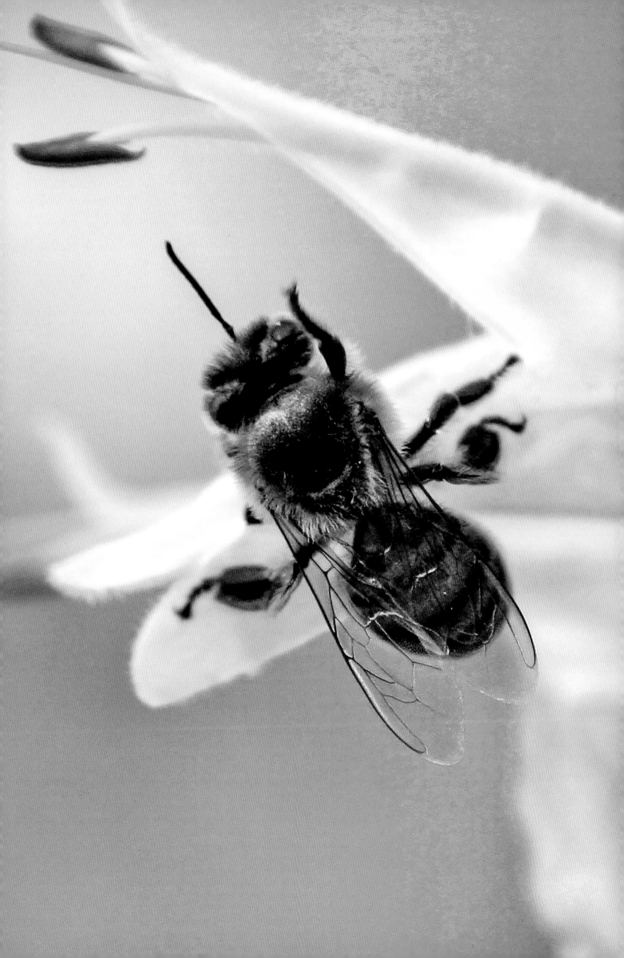

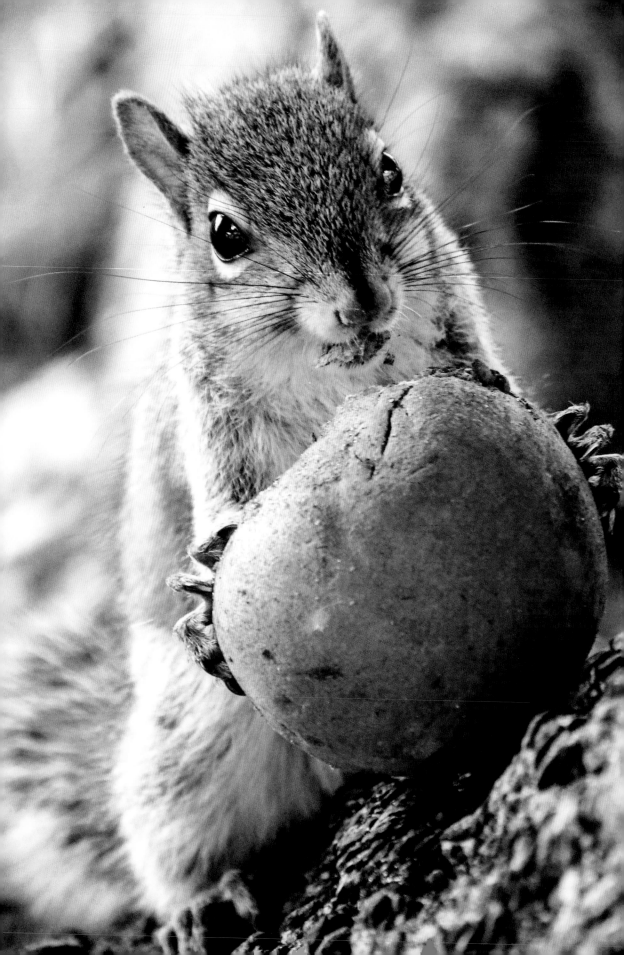

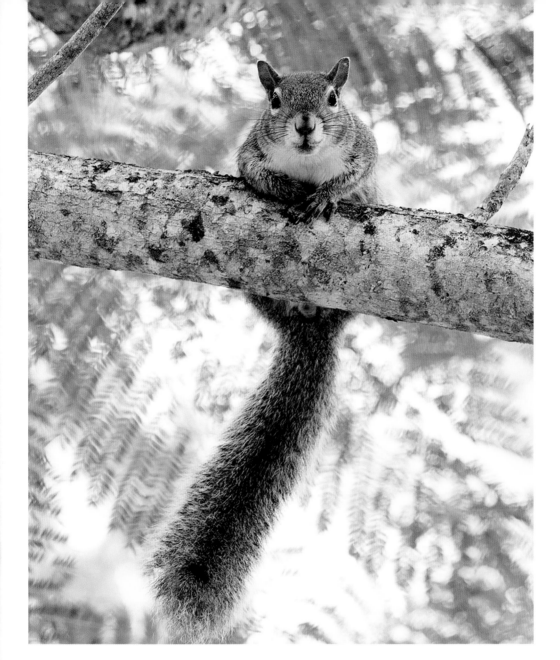

Morning Munchies *(facing page)*

A Florida brown squirrel munches on a piece of kiwi fruit while trying to roll it up a tree at Bonnet House Museum & Gardens on January 30, 2016. I used a Canon EOS 70D camera and a Canon 55–250mm lens set to a focal length of 250mm. With an ISO rating of 1600, my exposure was $^1/_{250}$ second at f/5.6.

Perfect Squirrel Portrait *(above)*

A Florida brown squirrel poses for a formal portrait at Bonnet House Museum & Gardens on December 2, 2015. I used a Canon EOS 70D camera and a Canon 55–250mm lens set to a focal length of 123mm. With an ISO rating of 400, my exposure was $^1/_{250}$ second at f/6.3.

Tadpoles *(facing page)*

A swarm of tadpoles swims just below the surface of a lily pond over a gold, submerged leaf at Bonnet House Museum & Gardens on July 28, 2015. I used a Canon EOS 40D camera and a Canon 55–250mm lens set to a focal length of 146mm. With an ISO rating of 400, my exposure was $^1/_{250}$ second at f/5.6.

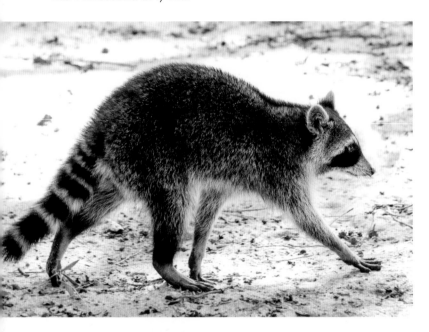

Raccoon *(top left)*

A raccoon saunters past the picnic tables at Bonnet House Museum & Gardens on January 26, 2016. I used a Canon EOS 70D camera and a Canon 55–250mm lens set to a focal length of 131mm. With an ISO rating of 1600, my exposure was $^1/_{320}$ second at f/6.3.

Resting Raccoon *(bottom left)*

A winded and panting raccoon takes a break from the Florida heat after a quick run through the unoccupied picnic area at Bonnet House Museum & Gardens on January 26, 2016. I used a Canon EOS 70D camera and a Canon 55–250mm lens set to a focal length of 131mm. With an ISO rating of 1600, my exposure was $^1/_{250}$ second at f/5.6.

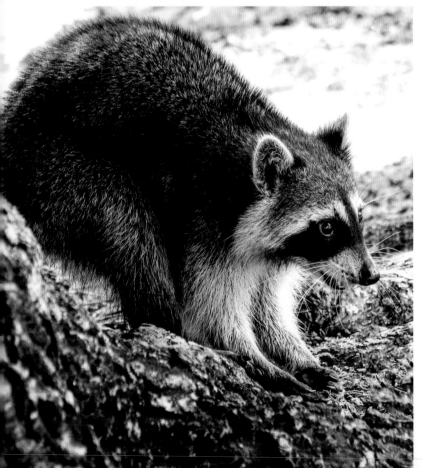

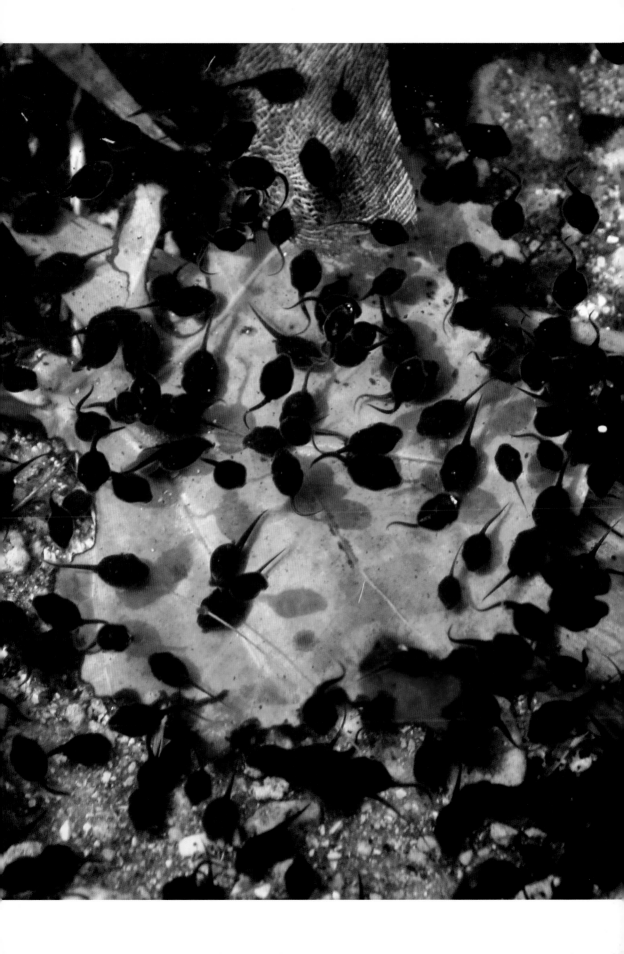

10. Activities and Environs

The Golden Gate (bottom left)

A wrought iron gate, painted gold, protects the main courtyard of Bonnet House Museum & Gardens. Here, it glows in the direct rays of the late afternoon sun on February 26, 2016.

The Canon 55–250mm lens on my Canon EOS 70D camera was set to a focal length of 208mm. Using an ISO rating of 1600, my exposure was $1/1300$ second at f/11.

Bonnet House Front Gate (bottom right)

The front gate at Bonnet House Museum & Gardens (and the dirt road leading away from it) was photographed shortly before it was opened on the morning of April 9, 2015. The Sigma 17–70mm lens on my Canon EOS 20D camera was set to a focal length of 23mm. Using an ISO rating of 400, my exposure was $1/250$ second at f/8.

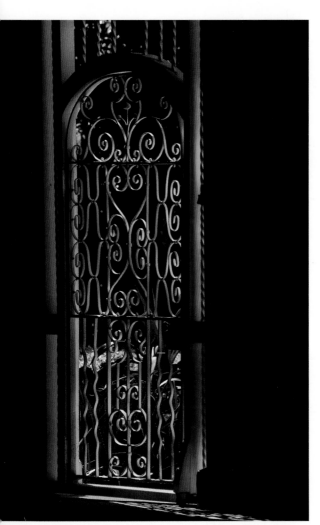

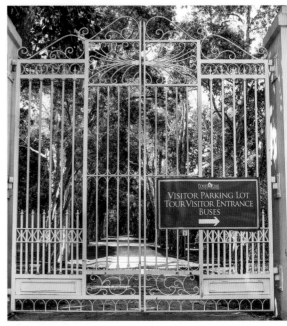

VISITOR PARKING LOT
TOUR VISITOR ENTRANCE
BUSES

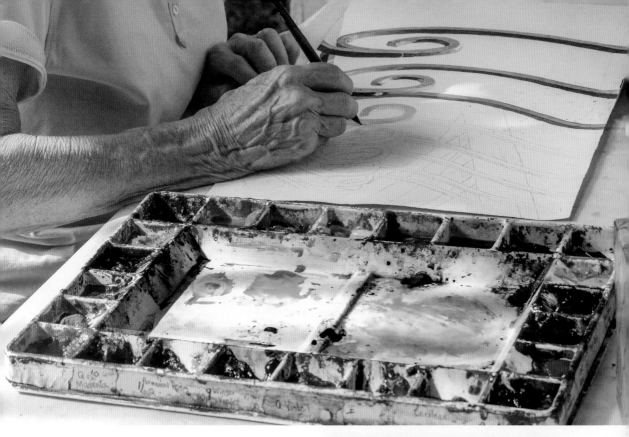

Art Class with Watercolors (above)

A student in one of the watercolor art classes offered at Bonnet House Museum & Gardens captures the beauty of one of the courtyard's gold, wrought-iron window decorations. I captured this on February 3, 2016, using a Canon 70D camera with Canon 55–250mm lens set to a focal length of 70mm. With an ISO rating of 1600, my exposure settings were $^1/_{640}$ second at f/10.

Bonnet House Artist (right)

Karen Eskensen, a Bonnet House Museum & Gardens art instructor and artist, begins to capture the beauty of violet orchids on display to the public on April 14, 2015. I used a Canon 40D camera with Sigma 17–70mm lens set to a focal length of 50mm. With an ISO rating of 400, my exposure settings were $^1/_{500}$ second at f/2.8.

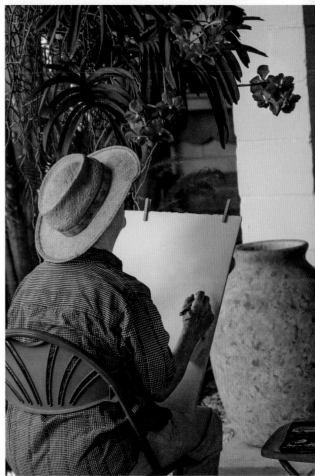

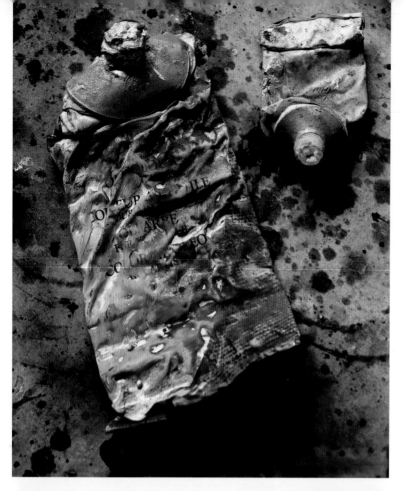

Paint Tubes *(top left)*

Two aging tubes of oil paint, last used in the 1950s by artist Fredric Clay Bartlett, are currently on display in his majestic two-story Bonnet House studio. I photographed them on January 26, 2016. I used a Canon 70D camera with Sigma 17–70mm lens set to a focal length of 30mm. With an ISO rating of 1600, my exposure settings were $^1/_{200}$ second at f/8.

Art Class Supplies

(bottom left)

A color test pad, brushes, watercolor paints and a dust-free eraser are carefully balanced during an art class being taught in the main courtyard at Bonnet House on February 10, 2016. I used a Canon EOS 70D camera with a 55–250mm Canon lens set to a focal length of 60mm. Using an ISO rating of 1600, my exposure was $^1/_{500}$ second at f/10.

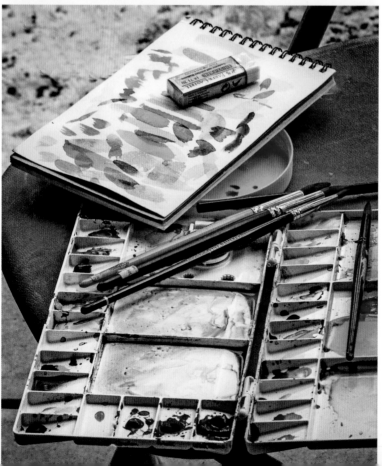

Chickee Reflection

(top right)

Near the bottom of the Bonnet House Museum & Gardens Chickee Bridge, partially decayed wooden boards and the stony shoreline are reflected in the large lily pond. I photographed this on March 25, 2015, using a Canon EOS 40D camera and a Sigma 50–500mm lens set to a focal length of 226mm. With an ISO rating of 1600, my exposure was $\frac{1}{250}$ second at f/5.6.

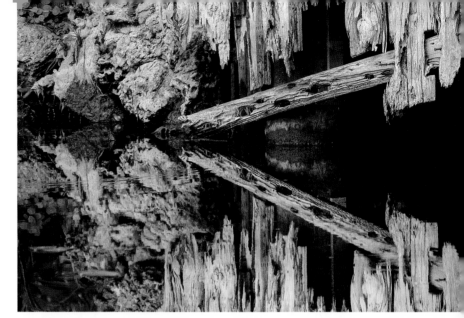

Chickee Bridge and Lily-Packed Pond

(bottom right)

An abundance of closely packed water lilies appear to fill much of the pond near the wooden Chickee Bridge at Bonnet House Museum & Gardens on September 12, 2015. I used a Canon EOS 40D camera and a Canon 55–250mm lens set to a focal length of 84mm. With an ISO rating of 400, my exposure was $\frac{1}{60}$ second at f/10.

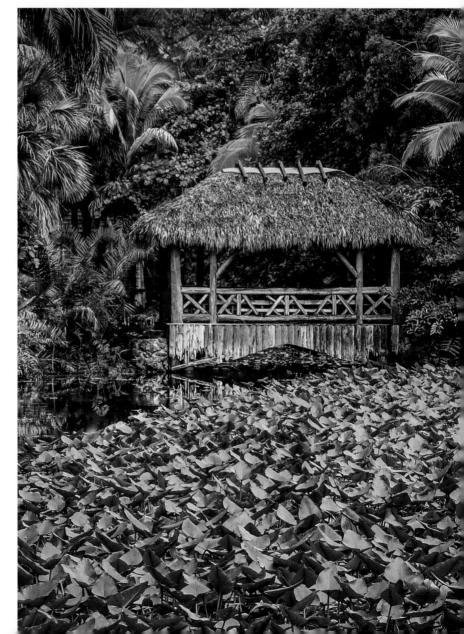

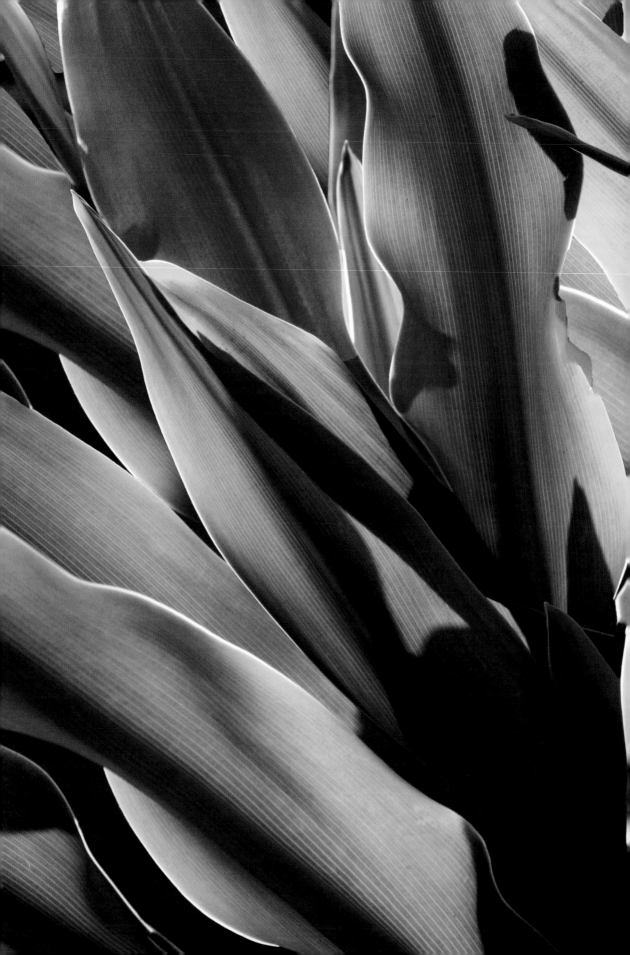

Index

Digital Black & White Landscape Photography

Trek along with Gary Wagner through remote forests and urban jungles to design and print powerful images. *$34.95 list, 7.5x10, 128p, 180 color images, order no. 2062.*

The Complete Guide to Bird Photography

Jeffrey Rich shows you how to choose gear, get close, and capture the perfect moment. A must for bird lovers! *$29.95 list, 7x10, 128p, 294 color images, index, order no. 2090.*

Wildlife Photography

Joe Classen teaches you advanced techniques for tracking elusive images and capturing magical moments in the wild. *$34.95 list, 7.5x10, 128p, 200 color images, order no. 2066.*

Photographing Water

Heather Hummel walks you through techniques for capturing the beauty of lakes, rives, oceans, rainstorms, and much more. *$37.95 list, 7x10, 128p, 280 color images, index, order no. 2098.*

Black & White Artistry

Chuck Kimmerle shares some of his most evocative images and teaches you his creative approach to re-envisioning places and spaces. *$37.95 list, 7x10, 128p, 205 color images, index, order no. 2076.*

How to Take Great Photographs

Acclaimed photographer and instructor Rob Hull reveals the secrets of outstanding lighting, composition, and more. *$29.95 list, 7x10, 128p, 150 color images, index, order no. 2099.*

Conservation Photography Handbook

Acclaimed photographer and environmental activist Boyd Norton shows how photos can save the world. *$37.95 list, 8.5x11, 128p, 230 color images, index, order no. 2080.*

Macrophotography

Biologist and accomplished photographers Dennis Quinn shows you how to create astonishing images of nature's smallest subjects. *$37.95 list, 7x10, 128p, 180 color images, index, order no. 2103.*

Mastering Composition

Mark Chen explores a key step in the creation of every image: composition. Dive deep into this topic and gain total control over your images. *$37.95 list, 7x10, 128p, 128 color images, index, order no. 2081.*

How to Photograph Bears

Joseph Classen reveals the secrets to safely and ethically photographing these amazing creatures in the wild—documenting the beauty of the beast. *$37.95 list, 7x10, 128p, 110 color images, index, order no. 2112.*